Nsenga A. Knight
<u>Come Clean</u>

Using water and at least two additional materials or
substances amounting to any odd number, clean everything in
one entire room.

This performance may be executed with the assistance of an
audience.

A

Jacolby Satterwhite
Look at Me

Invert the male gaze in art history and create a subject and object relationship between two black men — it will parallel the relationship between models and artists throughout art history that have been critically analyzed frequently. For example, Vermeer and The Girl with the Pearl Earring, Manet and Olympia, Balthus and his young female models, Gauguin and his Tahitian Models, Yves Klein and his female models as painting utilities, or even David Hockney and his male muse/lovers that were drawn frequently. The black male-on-male gaze has been a neglected critical dialogue in art history and literature. Romanticizing the model and artist relationship roots back to the story of Pygmalion, the sculptor who became obsessed with his statue, until she came to life. There are essays on the problematic gaze of Robert Mapplethorpe and his black male models. There are even bodies of work created by black male artists trying to reclaim their agency from that body of work. The Girl with a Pearl Earring is a timeless story about a model and a painter. Women have dwelled on how their bodies are looked at in the studio as a platform for critical discourse for decades. There are volumes of queer theory that analyze when a black man serially paints another man for a decade and it only gets acknowledged for its historical subversions, and glorification of an adversarial group. The evasiveness alone is worth an essay.

In response to this issue, two black male artist are going to be placed in a studio with 24 objects and will be given 24 hours to make a body of work together in that limited amount of time. Take notes about the nuances that happen between these exchanges and write a paragraph about your experience afterwards.

Graphite, laptop, digital camera, paper, paint, canvas, wood, fabric, colored tape, a box of miscellaneous thrift store variables

Options (Make sure this is under video surveillance)
#1. Choreograph your model
#2. Draw or paint your model
#3. Talk about art with your model
#4. Photograph your model
#5. Sculpt your model
#6. Use your model's body as a site for art making
#7. Cook dinner for your model and eat with them

#8. Exchange personal histories with each other
#9. Explain each other's sexual persona, preference, backgrounds to one another
#10. Make a collaborative provisional sculpture and painting
#11. Interview your model
#12. Dance for and entertain your model
#13. Sing a duet with your model

Maren Hassinger
<u>Repose</u>

I'm thinking of simple rest, not meditation of any sort.
Simple relaxation----a reprieve from action.

5 positions of repose with 1 sigh to repeat 5 times. The
length of time in each pose can vary. The first round may be
very fast and the last round may be very slow and boring.
Each pose can vary in length as well. Pose 1 can always take 3
minutes or not.

The whole cycle (or a part) can be repeated as a coda to other
scores and you may ask for audience accompaniment and you may
add a position of your own invention.

All to take place scattered within the room.

Position 1
Sitting straight up, your back near the wall to the left of
the main door and your legs straight out on the floor in front
of you, arms relaxed on either side of your legs. It could be
a day at the beach and the sand would be warming your legs.

Position 2
Against the rear wall your back is supported, your knees are
held close to your chest because your arms are around your
knees. Your feet rest on the floor a few inches from your
butt. You could be leaning against a tree trunk looking at a
vast savanna.

Position 3
In the middle of the room you lie flat on your back, arms
behind your head. Your knees are bent in a comfortable
position; your feet are on the floor. Your body is on a
diagonal line between the left rear corner and the right front
corner. It's as if you're watching clouds float by overhead.

Position 4
Your body is stretched out on its left side adjacent to the
right wall. The soles of your feet face the back wall and the
top of your head faces the door. Your right leg is on top of
your left leg; feet are comfortable. Your left hand can either
support your head by bending your elbow or you can simply
stretch that arm out on the floor perpendicular to your body
on the floor. In this second arm option your head would rest
on the arm as the arm rests on the floor. Here is when you

SIGH audibly. You might be watching something repetitive and soothing like ripples in a pond.

Position 5
Near the front door in the center of the room you sit upright with knees bent to either the right or left, depending on the most comfortable position for them. Your hands support you in the most comfortable position for them. It's as if you're sitting at a picnic on the grass.

Steffani Jemison
Regret piece

Experience regret.
Do not apologize.

D

Coco Fusco
Untitled

Go to the Transit Museum in Brooklyn and find the old subway
car from the mid-1960s in the basement. Re-stage scenes from
LeRoi Jones' *Dutchman* in the subway car. Wear a white oxford
shirt, tie and dark suit. Instead of a working with a blond
American woman, work with an Asian woman as your interlocutor,
dressed in a kitsch version of the all-American girl: blond
wig, miniskirt, oversized jacket, etc. Be sure she does that
crazy dance in the famous scene, viewable at: http://www.
youtube.com/watch?v=b9Ql7OrrfCY

Take black and white pictures.

Sanford Biggers
Lift Ev'ry Voice

1. Teach 11 people the history of the Black National Anthem, "Lift Ev'ry Voice And Sing."

"Lift Every Voice and Sing" (now also known as "Lift Ev'ry Voice and Sing") was publicly performed first as a poem as part of a celebration of Lincoln's Birthday on February 12, 1900 by 500 schoolchildren at the segregated Stanton School. Its principal, James Weldon Johnson, wrote the words to introduce its honored guest Booker T. Washington.

The poem was later set to music by Mr. Johnson's brother, John, in 1905. Singing this song quickly became a way for African Americans to demonstrate their patriotism and hope for the future. In calling for earth and heaven to "ring with the harmonies of Liberty," they could speak out subtly against racism and Jim Crow laws—and especially the huge number of lynchings accompanying the rise of the Ku Klux Klan at the turn of the century. In 1919, the NAACP adopted the song as "The Negro National Anthem." By the 1920s, copies of "Lift Every Voice and Sing" could be found in black churches across the country, often pasted into the hymnals.

During and after the American Civil Rights Movement, the song experienced a rebirth, and by the 1970s was often sung immediately after "The Star Spangled Banner" at public events and performances across the United States where the event had a significant African-American population.

2. Teach the same 11 people how to sing "Lift Ev'ry Voice and Sing."

3. Have them sing it in unison (place and length to be determined by the "conductor").

4. With different people, repeat often.

Lift Ev'ry Voice And Sing Lyrics
Written by James Weldon Johnson c.1900

Lift every voice and sing,
Till earth and heaven ring,
Ring with the harmonies of liberty;
Let our rejoicing rise

F

High as the listening skies,
Let it resound loud as the rolling sea.

Sing a song full of the faith that the dark past has taught us,
Sing a song full of the hope that the present has brought us;
Facing the rising sun of our new day begun,
Let us march on till victory is won.

Stony the road we trod,
Bitter the chastening rod,
Felt in the days when hope unborn had died;
Yet with a steady beat,
Have not our weary feet
Come to the place for which our fathers died?
We have come over a way that with tears have been watered,
We have come, treading our path through the blood of the
 slaughtered,
Out from the gloomy past,
Till now we stand at last
Where the white gleam of our bright star is cast.

God of our weary years,
God of our silent tears,
Thou who hast brought us thus far on the way;
Thou who hast by Thy might, led us into the light,
Keep us forever in the path, we pray.
Lest our feet stray from the places, our God, where we met
 Thee;
Lest our hearts, drunk with the wine of the world, we
 forget Thee,
Shadowed beneath Thy hand,
May we forever stand,
True to our God,
True to our native land.

Jennie C. Jones
<u>Score Against Sustained Ideas (Getragen)</u>

CLAP — 1: to strike (as two flat hard surfaces) together so as to produce a sharp percussive noise 2: to strike (the hands) together repeatedly usually in applause 3: to strike with the flat of the hand in a friendly way 4: to place, put, or set especially energetically 5: to improvise or build hastily 6: to produce a percussive sound; slam 7: to go abruptly or briskly

HUM — 1: to utter a sound like that of the speech sound \m\ prolonged 2: to drone 3: to give forth a low continuous blend of sound 4: to be busily active "the museum hummed with visitors"

SNAP — 1: to make a sudden closing of the jaws 2: to grasp at something eagerly 3: to utter sharp biting words-bark out irritable or peevish retorts 4: to break suddenly with a sharp sound 5: to give way suddenly under strain 6: to make a sharp or crackling sound 7: to move briskly or sharply 8: to undergo a sudden and rapid change (as from one condition to another)

MOVE — 1: to go or pass to another place or in a certain direction with a continuous motion 2: to proceed toward a certain state or condition 3: to become transferred during play 4: to keep pace 5: to depart 6: to change one's residence or location 7: to carry on one's life or activities in a specified environment 8: to change position or posture 9: to take action, act 10: to make a formal request, application, or appeal

G

| 1890 | JAPANESE PRINTS | Gauguin d. 1903 | Cézanne | Seurat d. 1891 | 1890 |

1890 — Gauguin d. 1903 — SYNTHETISM 1888 Pont-Aven, Paris — Cézanne Provence d. 1906 — Seurat d. 1891 NEO-IMPRESSIONISM 1886 Paris — 1890

Van Gogh d. 1890

1895 — Redon Paris d. 1916 — Rousseau Paris d. 1910 — 1895

1900 — 1900

NEAR-EASTERN ART

1905 — FAUVISM 1905 Paris — NEGRO SCULPTURE — CUBISM 1906–08 Paris — 1905

1910 — (ABSTRACT) EXPRESSIONISM 1911 Munich — FUTURISM 1910 Milan — MACHINE ESTHETIC — ORPHISM 1912 Paris — SUPREMATISM 1913 Moscow — 1910

1915 — (ABSTRACT) DADAISM Zurich Paris 1916 Cologne Berlin — Brancusi Paris — DE STIJL and NEOPLASTICISM Leyden Berlin 1916 Paris — CONSTRUCTIVISM 1914 Moscow — 1915

PURISM 1918 Paris

1920 — 1920

BAUHAUS Weimar Dessau 1919 1925

1925 — (ABSTRACT) SURREALISM 1924 Paris — MODERN ARCHITECTURE — 1925

1930 — 1930

1935 — NON-GEOMETRICAL ABSTRACT ART — GEOMETRICAL ABSTRACT ART — 1935

Source: The Museum of Modern Art, New York

Xaviera Simmons
<u>**One After The Other After The Other and So On.**</u>

Viewing Richard Serra's "Hand Catching Lead" 2:59 minute video performers construct a work in conjunction with Serra's Piece

This score must be performed by at least 3 performers but preferably more than 3 but no more than 9.

Performers must not have viewed this video for this purpose or rehearsed this piece beforehand.

The performance environment/stage should include either one large projection of Serra's video "Hand Catching Lead" or one large projection and a monitor in front of every performer so that he/she may view the video to work on the program or two monitors per performer; one facing the audience members and one monitor facing the performer that are synced together.

The performance commences at the start of the video, performers must use their entire body to "answer" or "mimic" the movements of Serra, moment by moment, movement by movement and each movement must be different from the other. Performers may repeat certain movements after they have produced 3 newer movements.

The finale of this piece occurs only after all the performers are able to perform with their entire bodies in sync with Serra's video, moment by moment. The performers must have a movement in sync with every moment or movement of Serra's piece. The movements should be clear and direct.

This score requires the movement of the performer's entire body to mimic the movements found in Serra's Video.

The performers must wear skintight black body suits or leggings and tight black long sleeved shirts or tank tops and the performers must have real white animal fur wrapped around their necks.

There is no time limit on this score. The performance and movements must not end until all performers have synced their bodies' movements with those of Serra's exactly.

Dave McKenzie
<u>Untitled</u>

Pick a corner of the room and place yourself in it and
against it.
Try to conjure up a past that isn't your own.

Get ready to move.
Don't think too long about what you might do.
Now act!

Stop!
Now think about the future after you.
Make a phone call.

Derrick Adams
"How To Preserve Your Sexy" borrowed from the words of P-Diddy
"And You'll Need A Hand Towel"

Avalon Organics Vitamin C Refreshing Cleansing Gel
Directions for use: Add a small amount of cleanser to dampened
palm and work into a creamy lather. Gently massage over face
and neck. Rinse clean.
Size: 8.5 fl oz (250 ml)

Price: $10.95

Avalon Organics Vitamin C Balancing Facial Tone
Directions for use: After cleansing, dampen a cotton pad with
toner and gently wipe face and neck. Follow with your favorite
moisturizer.
Size: 8.5 fl oz (250 ml)

Price: $10.95

Avalon Organics Vitamin C Moisture Plus Lotion SPF 15
Directions for use: Perfect for daily use, apply to clean face
and body, reapply as needed.
Size: 4 fl oz (100 ml)

Price: $16.95

J

Aisha Cousins
III. How to Listen to Lil Wayne (for Nia, Nya, and Kamaria)

You will need:

1 Lil Wayne song
2 pieces of cotton

Performance:
Place cotton in ears. Play song. Remove cotton.

*Re-invent as needed.

(Fin)

(If you have not heard about Nia, Nya, Kamaria, and Lil Wayne, please click here http://newsone.com/nation/dcharnas/watoto-from-the-nile-interview-open-letter-lil-wayne-girls/)

Saya Woolfalk
<u>Untitled</u>

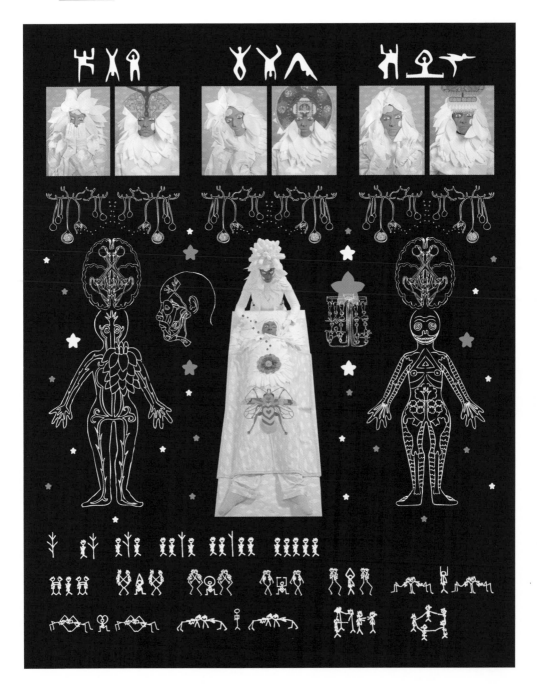

William Pope.L
<u>Untitled</u>

Be African-American. Be very African American

Glenn Ligon
Untitled

Annotate an existing performance/score. Perform that
performance annotated.

For example: Yvonne Rainer dancing "Trio A" while telling the
audience what she is feeling as she is doing it, what moves
she can't do because she is older, etc.

Senga Nengudi
Sweep

Sweep is built on the premise that pretty much most people worldwide, from the age of 2 up have engaged in the activity of sweeping. Sweeping stuff up is a common thread through all cultures. It may be meditative as well as satisfying and even creative.

For this performance you are using sand as the substance to be manipulated by the broom that you sweep into ever changing forms/designs. You may do as many forms as you like. But I think three should probably be sufficient.

After completing the third form ask someone in the audience to join you to create their own design.

Particulars
This performance works best on a concrete or cement floor.

You will need
50lb bag of regular all purpose sand. Play Sand is okay. It is usually whiter and of a finer grain.
2 regular brooms: Paint the brooms two tone, top half dark blue, bottom half turquoise or close to it. Painting of the brooms is optional.
1 jar of dark blue powdered tempera.
1 plastic spray bottle—this you will fill with water to spray on the sand to keep the dust down.
Assortment of stuff to place in or on sand designs once completed to bring a shift in meaning.
 Suggestions
 African sculpture or mask or curio of any kind
 McDonald's toy from Happy Meal
 Newspaper Headline
 Photo of someone
 Whatever
 Onlookers may add something from their own purses or
 person to accentuate the design.
Again this is optional. You may add one, several or none at all to the designs.

Mechanics

When opening the bag of sand, split it down the middle and
gently pour it out to prevent dust circulating in the air.
Spray a bit of water on the sand before you begin.

Divide sand into two mounds. You will work with the first
pile. The second pile sweep to the side. This pile will be for
the participant from the audience.

Then go for it! Simple forms are the easiest and most
dramatic. I will send you some examples. Practice with the
sand a bit before the performance to sort of develop your own
vocabulary.

Before you call the willing participant up take about 1/2 to
2/3rds of the contents from the powdered tempera jar and pour
it onto the participant's mound. Then let them go for it. Once
their design is complete that is the end of the performance.

*Remember to periodically spray the sand for both of you.

Sherman Fleming
Brando Apocalypse

Materials:
14 gallons assorted Interior wall paints
1 gallon high gloss latex interior black
5 rollers
5 roller handles
2 paint trays
5 tray liners
Space: Interior space area, white wall that measures 10′ x 12′

Setup:
1. Paint cans are stacked in pyramid fashion 10′ from center
 of wall. The paints are different shades of white with
 respective titles. Cans are arranged so that the colors
 of each can of paint label are clear to the viewer. Roller
 handles with rollers attached are put in center of stacked
 cans, paint trays arranged around cans.
2. Before action begins, the word, NIGGER, is painted, caps,
 on wall that fills the 10′ x 12′ area. NIGGER is sans
 serif font (helvetica bold) and is painted with hi-gloss
 black enamel.

Action:
3. Owens selects paint from one of the cans, pours it into a
 tray (paint should be poured away from the label of the
 paint, so that when/if the paint drips down the side of
 can the name of the paint is still legible.)
4. Owens begins at one end of the wall and paints the entire
 wall (from left to right, or from right to left, top to
 bottom); his task is to paint over the word.
5. By the time he has finished applying one coat the next
 coat is ready to be applied.
6. Owens selects another shade (he can choose the order of
 paint used), pours it into a tray; selects another roller
 and, starting at the point where he first started painting,
 begins to add another layer of paint, repeating the same
 brush strokes, the same movements until he completes the
 next coat.
7. Owens repeats steps #4, #5, #6 until NIGGER is entirely
 painted out and there's no trace to be seen (by the naked
 eye).

```
Budget:
1 GAL. Sherwin Williams (SW) 'Black of Night'
       high gloss interior               $30
1 GAL. SW Classic Ivory                  $30
1 GAL. SW China Doll                     $30
1 GAL. SW Extra White                    $30
1 GAL. SW Natural Choice                 $30
1 GAL. SW White Tail                     $30
1 GAL. SW Pearly White                   $30
1 GAL. SW Indian White                   $30
1 GAL. SW Non Chalant White              $30
1 GAL. SW Smart White                    $30
1 GAL. SW Pure White                     $30
1 GAL. SW Everyday White                 $30
Paint Rollers @ $5.45 ea. (5)        $27.25
Roller Handle @ $3.00 ea. (5)        $15.00
Paint Roller extension pole @ $10.99 (2)  $22.00
Paint Tray                            $4.00
Paint Tray liners @ $.70 (10)         $7.00
--------------------------------------------------

TOTAL                               $435.25
```

Kara Walker
<u>**INSTRUCTION**</u>

French kiss an audience member. Force them against a wall and
demand Sex. The audience/viewer should be an adult. if they
are willing to participate in the forced sex act abruptly
turn the tables and you assume the role of victim. Accuse your
attacker. Seek help from others, describe your ordeal.
Repeat.

K
Sent while crossing a busy intersection

In the days leading up to the final MoMA PS1 performance, Clifford Owens and Kara Walker met to discuss Walker's performance score, INSTRUCTION, and its inherent challenges and polemics. Below is a revised version of her score as it developed via email correspondence between the two artists.

From: Kara Walker Studio
To: clifford owens
Sent: Saturday, March 10, 2012 8:32 PM
Subject: good to meet

Hi Clifford,
it was really good to meet you today and see your show. I left hungry, exhausted really-
as you must be, and really kind of inspired. Talking about the meaning of a piece doesn't
happen enough in my universe anymore.
I am trying to compile all my thoughts about our conversation and compose an
eloquent annotation or amendment to your work. I don't want it to feel like a half-assed
revision- but an honest distillation of all the things we discussed and the piece as you
have been performing it.

I will say, as a starting point, the audience should be encouraged to mill around the room
and feel okay about being central not peripheral, the video document suggested that they
hang around the wall and that is already a problem. making you the bull in the bull ring.

the revision i am working on is called
"settling the score"

any thoughts?

I'll send
more soon.

Best,
Kara

From: Kara Walker Studio
To: clifford owens
Sent: Saturday, March 10, 2012 9:28 PM
Subject: or this, more in keeping with the original.

Settling the Score

Clifford Owens enters a room filled with visitors to his show.
The visitors mill around amiably but with a heightened sense of anticipation. An article
has been written in which it is announced that Clifford will force one of them into a sex
act. Many are aware of this rumor, some are only just learning about the piece now at this
reading, they are perhaps worried that they will not know what to do, or how to resist,
should they be chosen.

Clifford will choose from the group and then
French kiss an audience member for an extremely long time.

Clifford will have to force the viewer from the middle of the room to the furthest wall.
and he will then have to demand Sex.

he will say words to the effect of "I'm gonna Fuck your brains out" or other over the top
language.
(The audience/viewer must must be an adult.)
"you know you want it baby! I am just doing this for you!"

The viewer may show signs of resistance, at which point Clifford will have to make another
choice.

If they show a willingness to participate in the forced sex act Clifford will pull away, kneel down and abruptly turn the tables and assume the role of victim.

He will weep and tear at his clothes and cry out "you think I am a big black buck is all you think I am!"

He will whisper "black rapist motherfucker" under his breath.

He will seek help from others describing his ordeal. He will describe how he submitted himself to their abuse, that he only wanted to make a good impression...

He may cry out in an exaggerated drawl in the direction of the press- lawyers security guards, curators or other enforcers- "This is nothin' but a Hiiiigh Tech Lynching!"

Repeat- from the top. .
[KW1]

Kara Walker
Kara Walker Studio

From: clifford owens
To: Kara Walker Studio
Sent: Saturday, March 10, 2012 10:09 PM
Subject: Re: try this on for size.

Thanks so much for the scores. I really appreciate your time. You've given me a lot to consider and think about. I have a lot to process before tomorrow afternoon. I will think more about this and decide which direction to go for the performance.

I will send you my thoughts tomorrow. Are you sure you don't want to think about performing with me? No pressure of course.

Cliff

From: Kara Walker Studio
To: clifford owens
Sent: Saturday, March 10, 2012 10:30 PM
Subject: Re: try this on for size.

Maybe. I could read the score at least.

From: clifford owens
To: Kara Walker Studio
Sent: Saturday, March 1, 2012 11:36 PM
Subject: Re: try this on for size.

That would be terrific, Kara! I really want you to do this. I will be there with you to support you and work through the piece with you. It would would be powerful and profound if you appeared in the performance. We could have you waiting in the office before the piece---it would be a great unexpected twist to the piece and a way to play with and respond to the controversy.

I'm certainly not going to sleep now!

Cliff

From: Kara Walker Studio
To: clifford owens
Sent: Sunday, March 11, 2012 1:31 AM
Subject: Re: try this on for size.

Sure. Or whatever happens.
Thought -could announce the original score as "this score no longer exists --" and read the score.

And/or

I Come in and read the new score- the one pasted below that has you muttering "black rapist motherfucker" and restlessly trying to complete the score. The kisses.

And/or my intervention at the point of kissing? (Adding this thought now.) To keep the pressure up that maybe you are unhinged. Maybe going "all the way" maybe ?

I don't perform really except readings and dancing - and this seems that this requires more physically from me. Some more movement if you think it does lets follow it- but not hurt one another!

Malik Gaines
The Only 1

THE ONLY 1

△
△ ○
△ ○ □
○
○ □
□ △
□

S

Rico Gatson
Five Minutes

Is inspired by the 1968 olympics medal ceremony where Tommie
Smith and John Carlos accept the gold and bronze medal in
the 200 meters while giving the black power salute. My score
is for Cliff to interpret the scene/ moment as he sees fit
dressed or not also according to his desires. The desired
duration of the piece would be five minutes.

Benjamin Patterson
<u>Untitled</u>

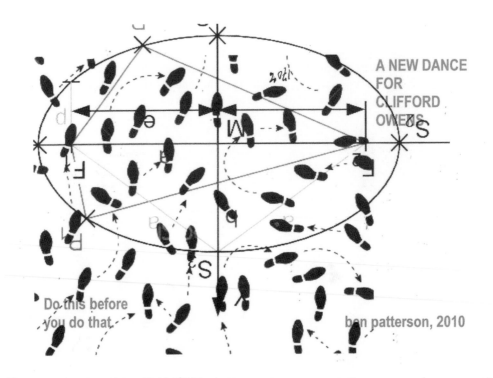

DO THIS BEFORE
YOU DO THAT.

Ben Patterson, 2010

Shinique Smith
A collection of words - Endeavoring to Create a Narrative -
For Cliff

to be expressed as directed by using the contents of the box
as you deem & as directed in No. 5

'Repetition creates bliss'

1. Open the box. Repeat excessively:
 'The rhythm, the rebel without a pause I'm lowering my
 level'

2. Mark a wall with <u>1985</u>… and flauntingly repeat this:

 Can't touch this
 Can't touch this
 Can't touch this

 Inspiration points:*
 Whitelock. North Ave. The Depot. City High. Natty Boh
 nights. The Harbor. Old Bay. UB Café. dread for home.
 Crackheads, first loves and fresh delusions. Regina,
 Shelly, Kelly, Kelly, Kelly.

3. Recite, however, in part or in full, doing whatever
 This act may be substituted by reciting a passage from
 any book in the box**

 <u>Indian Boy Love Song #3 (Sherman Alexie)</u>

 I remember when I told
 my cousin
 she was more beautiful

 than any white girl
 I had ever seen.
 She kissed me then
 with both lips, a tongue

 that tasted clean and un-
 clean at the same time
 like the river which divides
 the heart of my heart, all
 the beautiful white girls on one side,
 my beautiful cousin on the other.

W

4. Repeat with obsessive rhythm, with a partner:
 Two chairs facing each other will be needed in this
 portion***

 You Partner

 Too black, too strong
 Too black, too strong

 Black is, Black ain't
 Black is, Black ain't

 Beautiful Beautiful
 Beautiful Beautiful Boy

 You the man. No you the man.
 You the man. No you the man.

5. Using the contents of the box, on the area provided, create
 an object as an act of 'prayer' however you may define that
 act. Chanting the following or in silence:

 please please please
 let me let me let me

 Repeat, if desired, as often as you like.
 Then, close the box.

Contents of the Box
1- Suit
1- Can of Spray Paint
5- Rolls of Clothesline
1- Roll of Ribbon
5- Rolls of String
1- Dozen Pairs of Socks
1- Bottle of Water
1- Bag of Small Change
5- Bricks
1- Dozen Plastic Bags
1- Pillow with Case
1- Small roll of Carpet
5- Books
5- Bars of Soap
1- Mirror
1- Baseball Bat

3

4

Terry Adkins
Luxor Solo (Mystical Score for the Ghost of Bud Powell)

Luxor Solo attempts to recover and reenact luminous aspects of some mystical idiosyncrasies associated with the living spirit of pianist/composer Bud Powell. It is scored for a solo male performer wearing a black suit with white shirt and black tie, black shoes brilliantly shined and a red fez. He stands in a corner with a potted plant on a stand that is equal to his height.

After a 90 second period of silence standing next to the plant with his hands in his pockets, the performer repeats the words "Bud" and "Powell" slowly at first and gradually and periodically (surrendering to intuition) building into a cacophonic stutter of the name spoken as quickly as possible. Below is the rare image of Bud Powell that sparked this score:

Lyle Ashton Harris
<u>**Restating the Image: Construct #10, 1989, Lyle Ashton Harris**</u>

Requirement:
Performance is to be performed by Clifford Owens

Once image is shot, Owens is to recite memorized paragraph of
scholarly text on the image by Kobena Mercer in front of back
drop:

Mercer, Kobena. *Welcome to the Jungle: New Positions in Black
Cultural Studies*. London: Routledge 1994. 131, 222, 230-2.
Print.

Lorraine O'Grady
XENOSPHERE

xenosphere
— noun, coined Lorraine O'Grady 2010, from Gk. *xenos* "foreign, strange" + *sphaira*, "globe, ball" [zen-no´s-fear].

(DEFINITION: not required. But if collaborators wish to create their own, they may. If a definition is provided, it should be given in dictionary format and include an "example sentence" of the word's usage. The "author" of the usage sentence can be imaginary, or can be the collaborator, with the date that of the collaborator's performance of the piece.)

score for performance:

1. Think of an "Other" (animal, vegetable, or mineral).

2. Create a record (audio, visual, or text) of your interaction (real and/or imaginary) (intellectual and/or emotional) with this "Other."

3. Send a (low-res, low-tech, low-value) copy of this record of interaction to Lorraine O'Grady for her archive.

Anthology

Edited by Christopher Y. Lew
With contributions by John P. Bowles, Huey Copeland, Adrienne Edwards, and Thomas J. Lax.

MoMA PS1

Clifford Owens

This book is dedicated to my beautiful sons, Inti and Joaquin.

Anthology

Scores

Plates

Foreword

MoMA PS1 has earned an international reputation as a laboratory for experimentation and a space of invention. Beginning with its inaugural exhibition, it has also served as a site of production, encouraging artists to make work within the museum itself, often providing them with their own studio space. For four months during the summer of 2011, Clifford Owens made all of the works that comprise his *Anthology* project here at MoMA PS1, using the entire building. As his photographs and videos attest, Owens made use of nearly every inch of the museum, including the outdoor courtyard, basement, hallways, galleries, and rooftop. He energized the building with his performances and also challenged the institution and our audiences by addressing issues of race, the body, and art history.

For his first major exhibition as a curator at MoMA PS1, Christopher Y. Lew organized a two-fold project: *Anthology* is not just a museum exhibition, but also a series of live performances. The project suggests another way to present art, enlivening the traditionally static gallery presentation with action while contextualizing the performances through the installation of the resulting photographs and related works.

We are particularly grateful to The Museum of Modern Art's Wallis Annenberg Fund for Innovation in Contemporary Art through the Annenberg Foundation for their support of the exhibition and this publication. The presentation of *Anthology* at MoMA PS1 would not have been possible without the additional support of The Friends of Education of The Museum of Modern Art as well as that of Bernard Lumpkin and Carmine Boccuzzi. I would also like to acknowledge the generosity and vision of the MoMA PS1 Board of Trustees, under the leadership of Agnes Gund, and thank the New York City Department of Cultural Affairs and Commissioner Kate D. Levin; Helen M. Marshall, Queens Borough President; James Van Bramer, Council Member; and the Council of the City of New York for their support. I want to thank Glenn Lowry, Director of The Museum of Modern Art, for his guidance. I also thank Kathy Halbreich, Associate Director of The Musuem of Modern Art, who has been deeply engaged with the project since its inception. On Stellar Rays and Candice Madey also played a crucial role in realizing the project. Lastly I thank Clifford Owens for delivering such an important project, one that will continue to resonate.

Klaus Biesenbach
Director

Introduction

I make art in my head, from my heart, and through my body.

This project has been in my head for over a decade. In 2000, I conducted research on US-based black artists and performance art for a chapter of my graduate thesis. However, I failed to find adequate evidence that black artists have been invested in performance art since the 1950s. I knew this was not due to a lack of involvement. After all, a central figure to the formation of Fluxus was Benjamin Patterson, a black man born in Pittsburgh, Pennsylvania in 1934. To say the least, I was frustrated in my tireless pursuit to *mine* a legacy of performance art distinct from, but part and parcel to, a broader history of mid- to late-twentieth-century African American art. Rather than lament the lack of historical interest in US-based black artists and performance art, I chose to imagine my own history.

My heart was in this project. For six consecutive months of public performances, I was raw, intense, and fearless. During that time, I also suffered dark moments of personal crisis, but the luminosity of *Anthology* guided me through that gloom. This project saved my life.

Moreover, the twenty-six artists who contributed the scores that structure both the live performances and the exhibition drive the emotional gestalt represented in this body of work. I was the conduit for transmitting profoundly powerful messages from a group of enormously talented artists.

My body is attached to *Anthology*. It is the container and conveyor of its meaning. It functions as kind of liminal body. Through photography and video, the texts are made both implicit and explicit as a representation of a past moment that occurred in the presence of an audience, and in relation to the camera itself.

The presence of and engagement with the audience in the live performances was critical to this project. Audience members kissed me, kicked me, slapped me, embraced me, dragged me, hoisted me, humiliated me, humbled me, befriended me, loved me, hated me, harmed me, hurt me, moved me, touched me, abandoned me, rescued me, stalked me, harassed me, intimidated me, frightened me, abused me, used me, exploited me, repulsed me, and some would later fuck me. Of course, in the spirit of the "social contract" of performance art, it was all consensual.

Clifford Owens

Artist Acknowledgments

Without the love, support, generosity, and kindness of many people, I would have never completed this project.

First of all, I thank the talented artists who generously contributed the scores to *Anthology*. I could never fully express my heartfelt gratitude to and profound respect for each of you.

Christopher Y. Lew is much more than the brilliant, visionary curator of *Anthology*. He is my very dear friend whom I love, respect, and admire. Throughout this project, Christopher has supported me, in both personal and professional ways. His belief in my work has singlehandedly changed the course of my life as an artist.

I would also like to thank Kate Scherer. Kate was my production manager and without her assistance, deft organizational skills, razor-sharp mind, ability to anticipate my needs, and, above all, her friendship, I'm not sure how I would have managed to make it through this project.

For their kindness, care, and understanding, I would like to thank the entire staff at MoMA PS1. I would like to extend a very special thanks to Sixto Figueroa, Richard Wilson, David Figueroa, and Rebecca Taylor.

Support from my friend Matthew McNulty made this project possible. Matthew's commitment to *Anthology* and his respect for all the artists who contributed to its success reinforces his belief in the power of art to transform lives, his passion for art, and his courage to take risks. I would also like to thank AC Hudgins, Bernard Lumpkin, and Carmine Boccuzzi for their generous support.

My many conversations with Valerie Cassel Oliver and RoseLee Goldberg were very helpful in the early and late formation of this project. I would also like to thank several other curators and museum directors for their support: Kathy Halbreich, Klaus Biesenbach, Lowery Stokes Sims, and Thelma Golden.

Over the years, institutional support has been critical in the development of my practice as an artist. I'm especially grateful for support of MoMA PS1, the Studio Museum in Harlem, Skowhegan School of Painting and Sculpture, Contemporary Arts Museum Houston, and Performa.

Every artist should have mentors and I've been fortunate to have many over the years. For the past seventeen years Barbara DeGenevieve has always inspired me to be a better artist and person.

Since 2000, teaching has been an important part of my art practice. I'm thankful to my best students for engaging with my particular practice of pedagogy. You've taught me much more than I could ever teach you. There are too many talented young artists to list here, but they've studied with me at New York University, the School of the Art Institute of Chicago, Rutgers University, Yale University, Cooper Union for the Advancement of Art and Science, and the School of the Museum of Fine Arts, Boston.

To avoid unintentionally omitting the names of so many friends and artists who have greatly influenced and encouraged me since my youth in 1985, I would like to

thank those of you who have been or remain a significant part of my life at different points, in Baltimore, Maryland; Chicago, Illinois; New Brunswick, New Jersey; and the five boroughs of New York City.

For their love and support, I would like to thank my family in Baltimore: the Jenkins family and the Owens family.

Most of all, I thank my mother, Betty Owens, and my sons, Inti and Joaquin.

Clifford Owens

Acknowledgments

A curator can do little without a visionary artist and the courageous work he or she shares with the world. I hold Clifford Owens in deep gratitude and great esteem for not only the ambition to create a project like *Anthology*, but for the perseverance to see it through, despite all the numerous challenges that arose. The project is imbued with a giving spirit and it is manifested in the artists who contributed performance scores. I thank all of the artists involved. *Anthology* stands on the shoulders of their greatness and generosity. I thank Director Klaus Biesenbach and Curator Peter Eleey for their guidance throughout the process. Their belief in a project that had yet to be created, and willingness to support something sight unseen, made their commitment to the exhibition all the more significant. I am grateful for the support of the MoMA PS1 Board of Trustees, especially our Chairman Agnes Gund. I also thank The Museum of Modern Art Associate Director Kathy Halbreich for her support of *Anthology* from its early stages and through its development. Furthermore, without her confidence in the project, this publication would not have been possible.

I am thankful for the support of The Museum of Modern Art's Wallis Annenberg Fund for Innovation in Contemporary Art through The Annenberg Foundation to realize the exhibition and publication. The Friends of Education of The Museum of Modern Art also provided invaluable support. Bernard Lumpkin and Carmine Boccuzzi were generous in every possible way; their excitement and encouragement energized everyone around them.

I thank Huey Copeland and John Bowles for their thoughtful, probing essays for this book. I also thank Kellie Jones and the roundtable participants—Derrick Adams, Terry Adkins, Sherman Fleming, Maren Hassinger, Steffani Jemison, and Lorraine O'Grady—for a moving and enlightening conversation. I am also grateful for the countless hours Adrienne Edwards and Thomas J. Lax put in to conduct the interviews for the volume. Elaine Carberry, Gary Carrion-Murayari, Ryan Inouye, Bernard Lumpkin, Matthew McNulty, Kate Scherer, Gabi Scopazzi, Lanka Tattersall, and Eugenie Tsai took time to speak about their recollections and thoughts of the live performances. Diana Hill, Liza Eliano, and Jocelyn Miller transcribed those conversations with great precision. Rumors, led by Andy Pressman, skillfully translated *Anthology* into the form of this book. Rachel Wetzler, as copyeditor, honed the content of the publication.

A project of this scale would not be possible without the help of many. Candice Madey and her team at On Stellar Rays—Nori Pao and Courtney Childress—worked tirelessly every step of the way. Patrick Gibson and Maureen Sullivan were also of much help throughout the process. I am also indebted to Matthew McNulty and his unwavering encouragement for and support of *Anthology*. The live performances would not have gone so smoothly, or at all, without Kate Scherer and her unerring production skills. Ruth Kahn, Fernando Feria Garibay, and the rest of Outpost Artist Resources provided invaluable time, equipment, and knowledge to edit and format the video works. I am grateful to many for generously lending their technical

expertise: Nimajus "Neo" Bagdonavicius, Amy Bench, Tony Bonilla and his team at BNW Rigging, Jake Borndal, Elba Calado, Élan Jurado, Maria Sofia Di Lenna, Erica Magrey, Sam Morrison, Alex O'Neill, and Roxie Turner.

My conversations with Eugenie Tsai, Jeremy Steinke, and Valerie Cassel Oliver, provided great insight throughout the course of the project. Many other individuals and organizations helped to facilitate the performances, exhibition, and publication. Among them, specials thanks are due to Elia Alba; Rocío Aranda-Alvarado; Lily Arbisser; Lauren O'Neill-Butler and Miriam Katz, *Artforum*; Alan Baglia, Artist Rights Society; Pamela Auchincloss; Nicole Awai; Naomi Beckwith; Nayland Blake; Rich Blint; Isolde Brielmaier; Cheri Ehrlich, Brooklyn Museum; Phong Bui, *The Brooklyn Rail*; Sabine Russ, *Bomb*; Hannie Chia, The Bronx Museum of the Arts; Michael Catapano; Nick Cave; Colby Chamberlain; Paul Chan; Ben Diep, Color Space Imaging; Foli Creppy; Mae Petra-Wong, CRG Gallery; Elisa Leshowitz, D.A.P./ Distributed Art Publishers; Kianga Ellis; Stephanie Pereira, Eyebeam; Brendan Fernandes; Tom Finkelpearl; Jacob Folayan; Nancy Grossman; Andria Hickey; Thelma and AC Hudgins; April Hunt; James Hyde; Raymond Johnson, Dietrice Bolden, Shawny Johnson, Jarrett Parker, and Craig Sidberry, Impact Repertory Theater; Kate Fowle, Renaud Proch, and Chelsea Haines, Independent Curators International; Jack Shainman and Tamsen Greene, Jack Shainman Gallery; Jack Tilton and Lauren Hudgins, Jack Tilton Gallery; Kyle Jean-Baptiste; Rashid Johnson; Nina Johnson-Milewski, Gallery Diet; Cynthia Daignault, Kara Walker Studio; Ruba Katrib; Leslie King-Hammond; Natalie Labriola; Shaun Leonardo; Isabelle Lumpkin; Kerry James Marshall; Rae Matthew; halley k harrisburg, Michael Rosenfeld Gallery; Wardell Milan; Daniel Milewski; Jay Gorney and Nicole Russo, Mitchell-Innes & Nash; Nathlie Provosty; John H. Murray; Elizabeth Hamby, Museum of the City of New York; Daisy Nam; Eungie Joo and Kimberley Mackenzie, New Museum; Andrea Scott, *New Yorker*; Daniel Newman and Barbara Bulleti Newman; Larry Ossei-Mensah; Kamau Amu Patton; Marissa Perel; RoseLee Goldberg, Esa Nickle, and Lana Wilson, Performa; John Pilson; Robert Pruitt; Kennon Kay, Leah Retherford, and Keha McIlwaine, Queens County Farm; Trina McKeever, Richard Serra Studio; Todd Rosenbaum; Betye Saar; Georgia Sagri; Jennifer Salomon; Trevor Schoonmaker; Brent Sikkema and Meg Malloy, Sikkema Jenkins & Co.; Lorna Simpson; Lowery Stokes Sims; Franklin Sirmans; Robin Urban Smith; Amy Smith-Stewart; Nick Stillman; Natika Soward; Thelma Golden and Abbe Schriber, the Studio Museum in Harlem; Yona Backer, Third Streaming; Nicole Cosgrove, Danielle Linzer, Margot Norton, and Carda Burke, the Whitney Museum of American Art; Bradley Weekes; Curtis Willocks; Nate Young; and Chrissie Shearman, Yvon Lambert.

My colleagues at The Museum of Modern Art aided in the project on many levels. Cerrie Bamford brought the project to the attention of many enthusias-tic individuals. MoMA's graphic design department, especially August Heffner and Sabine Dowek, ensured all information was presentable. I also thank Sabine Breitwieser, Christophe Cherix, Doryun Chong, Carol Coffin, Michelle Elligott, Mark Epstein, Pablo Helguera, Amy Horschak, Claire Huddleston, Ana Janevski, Carolyn Kelly, Jonathan Lill, Nancy Lim, Barbara London, Erica Papernik, Eva Respini, Lauren Stakias, Rebecca Stokes, Gretchen Wagner, Wendy Woon, and Calder Zwicky.

The MoMA PS1 staff was instrumental in realizing this project. Peter Eleey provided insightful curatorial guidance at every step in the process. Todd Bishop, Angela Goding, and their team skillfully managed fundraising. Rebecca Taylor communicated the importance of the project with care and precision. Peter Katz and Celine Cunha ensured that operations and finances ran without a hitch. Ismael Mamadou made sure all information technology needs were met, and the combined efforts of Jocelyn Miller and Margaret Knowles prevented anything from slipping through the cracks. Zachary Bowman and Morgan Parker deftly handled the visitor experience and managed the large crowds attending the live performances. Everett Williams coordinated signage and event information with speed and diligence. Sixto Figueroa and his team tirelessly cared for the building, especially after oft-messy actions. My curatorial colleagues Jenny Schlenzka, Matthew Evans, Eliza Ryan, and Lizzie Gorfaine provided constant support as did Richard Wilson, David Figueroa, Ko Smith, and their team of art handlers. Jen Watson oversaw the safety of the works with the utmost vigilance. Ramona Aguado and her security team ensured the safety of all performers and audience members. Yun Joo Kang, Amanda Greene, Jane McCarthy, and Anna Dabney Smith contributed to the realization of the project during their time at MoMA PS1. I am also grateful to the MoMA PS1 interns who went above and beyond their usual duties to assist with the project: Hendrick Bartels, Casey Brander, Dana Brisbane, Kayla Camstra, Alexander Damianos, Blaise Danio, Liza Eliano, Joya Erickson, Izabela Gola, Franziska Glozer, Irena Kukric, Bonaventure Kwak, Kaitlin McAndrews, Mary Negro, Allison Rosen, Harrison Salton, Gabi Scopazzi, Aisha Stoby, Imogene Strauss, Katherine Swenson, and Reid Ulrich.

Last I thank Cindy Jenkins who has been a sounding board throughout the process and a steadfast partner in every sense.

Christopher Y. Lew
Assistant Curator

Mal d'Anthologie: Clifford Owens and the Crises of African American Performance Art[*]

Huey Copeland

Clifford Owens's 2011 MoMA PS1 exhibition, *Anthology*, compiles a selection of the twenty-six performance scores that he solicited from an intergenerational cast of African American artists, ranging from the elder statesmen Terry Adkins to emerging figures such as Saya Woolfalk. As Owens recounts, *Anthology* began as a frustrated response to the inadequate representation, the near invisibility, of black practitioners within dominant accounts of performance art history in the United States.[1] His point is baldly put, but nonetheless well taken: a casual flip through the pages of RoseLee Goldberg's 1996 survey of the genre reveals an enormous black absence—only highlighted, in this instance, by the inclusion of an Adrian Piper illustration—and underlines the value of a reparative historical project.[2]

Such projects are, by definition, belated.[3] Yet in many ways, Owens's timing and that of his sponsoring institution could hardly be better: *Anthology* records the sites and aims of African American performance art at a moment when US imperialism sports a brown face and when few aesthetic postures, no matter how radical their pedigrees, seem capable of gaining much political traction. Recent art-world phenomena provide ample testament to these contradictions. In the last decade, black artists of various stripes have benefitted from increasing representation within mainstream venues, thanks, in part, to discourses around globalization and post-racial identity that have rendered "black work" both commercially viable and discursively intelligible, if no less constrained.[4] At the same time, performance art

[*]

My title is, of course, meant to rhyme with that of Jacques Derrida's *Mal d'Archive*, published in English as *Archive Fever: A Freudian Impression*, trans. Eric Prenowitz (Chicago: University of Chicago Press, 1995). Not so clear are the debts that this essay owes to the guidance of Christopher Y. Lew, the vision of Clifford Owens, the research assistance of Luke Fidler, and the incisive commentaries of Janet Dees, Hannah Feldman, Ramón Rivera-Servera, Lorna Simpson, and Krista Thompson. As ever, they have my thanks.

1

Clifford Owens in Nick Stillman, "Clifford Owens" *Bomb* 117 (Fall 2011): 55.

2

RoseLee Goldberg, *Performance Art: From Futurism to the Present* (New York: Harry N. Abrams, Inc., Publishers, 1996), 173. Of course, there have been more racially inclusive attempts to frame the history of performance art of late—subsequent editions to Goldberg's text among them—as well as vital interventions within African American art history. See, for example, John Bowles, *African American Performance Art Archive*, 2010, <http://aapaa.org/>; Paul Schimmel, *Out of Actions: Between Performance and the Object, 1949–1979* (Los Angeles: Museum of Contemporary Art; London: Thames and Hudson, 1998); Cherise Smith, *Enacting Others: Politics of Identity in Eleanor Antin, Nikki S. Lee, Adrian Piper, and Anna Deavere Smith* (Durham: Duke University Press, 2011); *Radical Presence: Black Performance in Contemporary Art* (Houston: Contemporary Arts Museum Houston, 2012); and Lowery Stokes Sims, "Aspects of Performance in the Work of Black American Women Artists" in *Feminist Art Criticism: An Anthology*, eds. Arlene Raven, Cassandra L. Langer, and Joanna Frueh (Ann Arbor, MI: UMI Research Press, 1988), 207–25. However, a thoroughgoing scholarly examination of black contributions to performance art from an explicitly art-historical perspective has yet to appear.

3

Michael Hanchard, "Afro-Modernity: Temporality, Politics, and the African Diaspora" *Public Culture* 11.1 (1999): 245–68.

4

One touchstone for these discourses, especially within discussions of the post-racial, is Thelma Golden's introduction of the term "post-black" in the exhibition catalogue *Freestyle* (New York: The Studio Museum in Harlem, 2001), 14–15. I take my critical stance toward the notion of "black work" from Darby English, *Black Artists, Black Work? Regarding Difference in Three Dimensions* (Ph.D. diss., University of Rochester, 2002).

has been institutionally embraced, advanced, and spectacularized like never before, effectively roped into the high-end "experience" industry, as evidenced by the successes of Goldberg's Performa Biennial, launched in 2005, and Marina Abramović's star turns at blue-chip New York museums, first the Guggenheim in that same year and subsequently at The Museum of Modern Art in 2010.[5] These twin developments have helped open a discursive space between them in which black performative interventions and their political possibilities might be said to properly reside. Owens's project thus aims to both temporarily occupy and actively construct this long-neglected terrain, and in a format that makes a deep historical sense: as cultural theorist Brent Hayes Edwards argues, the black anthology most often serves not to confirm an existing canon but to found the very tradition that it ostensibly records.[6]

These considerations provide one basis for approaching Owens's *Anthology*, but they cannot explain the peculiar form his intervention has come to take or its multiple ramifications, which is my ultimate aim in the pages that follow. Rather than create an archive, write a history, or mount an exhibition focused on extant traces of black US performance, Owens solicited his collaborators to write brand-new scores, usually textual instructions for him and him alone. A few of these he has yet to enact; some others he has only performed; the majority, however, have been originated by Owens and compulsively documented in the photographs and videos that comprise the exhibition and make the artist their star. This framing conceit is, I think, both more coherent and less narcissistic than it might sound: in forwarding his own image as a threshold through which future histories of performance might pass, Owens aims to spectacularly undo the visual effacement of black bodies within those narratives while referring back to the work of practitioners whose contributions, both storied and forgotten, can now be freshly reckoned with on their own terms.

Of course, the exhibition's drive toward the accumulation of a totality of black artistic production risks abetting continued complacency where the subject of African American performance is concerned, satiating a taste for racial difference and quelling voices of racialized dissent. This is a particular pitfall of the anthological, which, Edwards argues, "delimits the borders of an expressive mode or field, determining its beginning and end points, its local or global resonance, its communities of participants and audiences."[7] Yet I would contend that Owens's *Anthology* also functions as a spur to further historical investigation precisely because its order and its inconsistencies internalize the status of black performance art within the archive, and because the artist offers himself up as a site of articulation that expands who and what might be encompassed within its scope.

Anthology's roster of participants begins to tell the tale. It registers the new vistas for practitioners of color that have opened up over the last twenty years, as well as a calculated orientation toward the brighter lights within the black artistic firmament

5
For a valuable consideration of the conditions of performance art now, see Amelia Jones, "Introduction: Performance, Live or Dead" *Art Journal* 70.3 (Fall 2011): 33–38.

6
Brent Hayes Edwards, *The Practice of Diaspora: Literature, Translation, and the Rise of Black Internationalism* (Cambridge: Harvard University Press, 2003), 44. Edwards's discussion and my own are informed by Theodore O. Mason, Jr., "The African-American Anthology: Mapping the Territory, Taking the National Census, Building the Museum" *American Literary History* 10.1 (Spring 1998): 185–198.

7
Edwards, 44.

circa 2011, the category "performance artist" be damned.[8] Owens's repertoire includes a diagrammatic dance score from the recently "rediscovered" Fluxus mastermind, musician, and performer Ben Patterson [pages U–V]; a "controversial" *INSTRUCTION* from the infamous Kara Walker, whose work is deeply performative even when not literally so [Fig. 1][9]; and a piece from Glenn Ligon, who is somebody, to be sure, but no performer at all: he usually eschews the visualization of the black body by introducing a host of material surrogates for it.[10]

Perhaps because of this, Ligon's script for Owens is arguably the most capacious and the most revelatory. Unlike the majority of the scores, his prompt does not enjoin the younger practitioner to perform a clearly delineated series of physical actions. Nor does it leave interpretation almost entirely up to the performer, as in the case of William Pope.L's coy yet ideologically charged imperative "Be African-American. Be very African American," which Owens could not help but render in contrary terms. Instead of picturing the black actor he hired to execute the score—who was instructed to walk through the museum while sharing personal confessions with his trailing audience—the artist presents a grid-like arrangement of photographs documenting the line of white tape running through MoMA PS1 that determined the performer's course [Fig. 2].[11]

Sidestepping such physical and philosophical temptations, Ligon asked Owens to "Annotate an existing performance/score" of his choosing and then to "Perform that performance annotated." These are directives that go straight to the heart of *Anthology*'s ambition to serve as a repository of black aesthetic interventions; they solicit the work's author to lay his own cards on the table, to fully disclose his particular investments within the history of black performance art, and to enter into the discursive fray around the ethics of reperformance within the museum.[12] As so often in Ligon's practice, which takes annotation as one of its central procedures, in this score, an artist is called upon to select, inhabit, and thereby revivify earlier material whose discursive coordinates enable a reckoning with the ongoing

8
Judith Butler's emphasis on notions of performativity in *Gender Trouble: Feminism and the Subversion of Identity* (New York: Routledge, 1990) has had profound ramifications across the arts and humanities, notably among interdisciplinary practitioners invested in black performance in its various guises—music, speech, photography, film—who are less bound by art-historical conventions when engaging works defined as performance art. Here, I have foremost in mind Fred Moten's radical reframing of black performativity, *In the Break: The Aesthetics of the Black Radical Tradition* (Minneapolis: University of Minnesota Press, 2003) as well as texts such as Nicole Fleetwood, *Troubling Vision: Performance, Visuality, and Blackness* (Chicago: University of Chicago Press, 2011); E. Patrick Johnson, *Appropriating Blackness: Performance and the Politics of Authenticity* (Durham: Duke University Press, 2003); and Catherine Ugwu, ed., *Let's Get It On: The Politics of Black Performance* (London: Institute of Contemporary Arts; Seattle: Bay Press, 1995).

9
Walker's score trades in the same economies of sexualized violence pictured in the silhouettes for which she is most renowned. The text reads: "French kiss an audience member. Force them against a wall and demand Sex. The audience/viewer should be an adult. If they are willing to participate in the forced sex act abruptly turn the tables and you assume the role of victim. Accuse your attacker. Seek help from others, describe your ordeal. Repeat." For an example of the ways that Walker's participation has contributed to *Anthology*'s visibility—and sensationalization—see Rozalia Jovanovic, "'You Know You Want It, Baby': Clifford Owens Is Joined by Kara Walker, in Her First Live Performance" the *New York Observer*, March 11, 2012 <http://www.galleristny.com/2012/03/you-know-you-want-it-baby-clifford-owens-is-joined-by-kara-walker-in-her-first-live-performance/>.

10
Huey Copeland, "Glenn Ligon and Other Runaway Subjects" *Representations* 113 (Winter 2011): 78.

11
Clifford Owens, conversation with the author, December 16, 2011.

12
In regards to questions of reperformance, see Rebecca Schneider, *Performing Remains: Art and War in Times of Theatrical Reenactment* (London: Routledge, 2011).

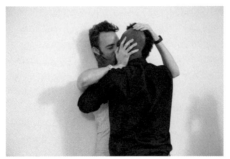

Fig. 1 Clifford Owens, *Anthology (Kara Walker)*
 (detail), 2011. 5 C-prints and HD video,
 C-prints: 16 × 24 inches each; video: 3
 minutes, 41 seconds, courtesy the artist.

Fig. 2 Clifford Owens, *Anthology*
 (William Pope.L) (detail), 2011.
 20 archival pigment prints,
 13 ½ × 9 or 9 × 13 ½ inches each,
 courtesy the artist.

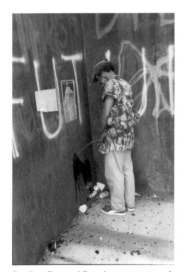

Fig. 4 Richard Serra, *P.S.1*, 1976. Steel, installation
 view at MoMA PS1. Photo: Matthew Septimus
 © 2012 Richard Serra / Artist Rights Society
 (ARS), New York

Fig. 3 Dawoud Bey, documentation of
 Pissed Off by David Hammons,
 1981. © Dawoud Bey

structural conditions of the past and the liabilities of the present for African American artists at work in the performative field.[13]

Owens's choice does not disappoint. Although he did not take on Yvonne Rainer's *Trio A*, to which Ligon refers in describing what an annotation might entail, he also did not veer too far from the beaten path, selecting a work by David Hammons, who helped legitimate performance as a site of inquiry for the generations of artists who followed in his wake.[14] Owens specifically lighted upon Hammons's 1981 intervention *Pissed Off*, in which the renowned artist—photographed all the while by his friend Dawoud Bey—urinated into a trash-filled corner of Richard Serra's 1980 sculpture *T.W.U.*, a work temporarily sited at the intersection of Franklin and Broadway in then-still-gentrifying Lower Manhattan [Fig. 3].[15] For his annotation, Owens climbed from his MoMA PS1 studio to the institution's roof where, with a hired photographer primed to capture every dribble and splash, he pissed on another Serra work, a 1976 site-specific sculpture created for the inaugural exhibition, *ROOMS*, back when P.S.1 was a crumbling schoolhouse under the aegis of the pioneering alternative space the Institute for Art and Urban Resources [Fig. 4].[16]

While the basic headline remains the same—black male artist bodily defaces work of sculptor Richard Serra—the multiple registers of difference separating these actions are worth spelling out. Hammons's target was a monumental public work, always meant to be relocated, whose imposing structure created a quasi-private space that fostered graffiti, postings, and his own alternate use [Fig. 5].[17] In irreverently vandalizing the sculpture, he both contested SoHo's transformation into an art world hub and marked the presence of those "undesirable" publics soon to be absented from its streets in consequence.[18] Owens, by contrast, let loose his stream on an unobtrusive steel trough sunken into the building that both hosted Hammons's 1991 retrospective and incorporated Serra's sculpture into its very structure. In so marking this territory, Owens at once perversely honored his "Daddies" and inscribed himself within the institutional framework supporting their practices and his own.

The images depicting each performance serve to exacerbate these positional, historical, and spatial discrepancies, which highlight, to borrow Rebecca Schneider's apt

13
On the importance of annotation in Ligon's work, see Huey Copeland, "Feasting on the Scraps" *Small Axe: A Caribbean Platform for Criticism* 38 (July 2012): 198–201.

14
The relevant passage from Ligon's score is: "For example: Yvonne Rainer dancing 'Trio A' while telling the audience what she is feeling as she is doing it, what moves she can't do because she is older, etc."

15
Harriet F. Senie, *The* Tilted Arc *Controversy: Dangerous Precedent?* (Minneapolis: University of Minnesota Press, 2002), 14–17.

16
Alanna Heiss, *ROOMS P.S.1* (New York: Institute for Art and Urban Resources, Inc., 1977). The most influential account of the works in this exhibition—several of which bear a striking affinity to Owens's *Anthology (William Pope.L)*—remains Rosalind Krauss "Notes on the Index: Seventies Art in America, Part 2" *October* 4 (Autumn 1977): 58–67. As will become clear, Krauss's emphasis on the photographic in that text is equally pertinent here.

17
Senie, 17.

18
For an account of *Pissed Off* and Hammons's other engagements with *T.W.U.* see Tom Finkelpearl, "On the Ideology of Dirt" in *David Hammons: Rousing the Rubble* (New York: Institute for Contemporary Art, P.S.1 Museum; Cambridge: MIT Press, 1991), 85–88. On the spatial transformation of Lower Manhattan and its attendant displacements in the 1970s and '80s, see Rosalyn Deutsche, *Evictions: Art and Spatial Politics* (Cambridge: MIT Press, 1996).

formulation, the "*theatricality* of time."[19] Bey's grainy black-and-white photographs document a clandestine action [Fig. 6]—in one shot, the tie-dyed-dashiki-wearing Hammons is seen explaining himself to a white police officer—while the images of Owens's work, carefully staged by the artist himself, expertly mime the *lingua franca* of contemporary large-format color photography [Fig. 7].[20] Unlike Hammons, he is situated safe within the confines of MoMA PS1, dressed in the artist's uniform of black shirt and jeans, openly displaying his penis and unfurling his stream [Fig. 8]. In one image his piss creates a golden arc that harks back to the S/M photographs of Robert Mapplethorpe; in another, the liquid forms a wet iridescent mark that recalls the oxidation paintings of Andy Warhol. Daddies, indeed.

At stake here is more than mere one-upmanship. Taken together, Ligon's score, Hammons's performance, and Owens's highly mediated queering of both gesture toward the questions underpinning, in the anthologist's words, the "crisis of meaning" confronted by "black U.S. artists working in the medium of performance," who "often find themselves farther at the bounds" of any notion of community, African American, aesthetic, or otherwise.[21] Where, how, and for whom should black performance unfold? What, if any, is its relationship to the art world and its economies of promotion, displacement, and canonization? Must African American performative interventions necessarily address the racialized exclusions of the public sphere to achieve sufficient critical weight and "colored" content? What is the valence of such actions when they unfold within and are in fact supported by institutions that have historically turned a blind eye to African American artists?

MoMA, which has been affiliated with P.S.1 since 2000, is well practiced in institutionalized blindness, as testified by its uneven collection and exhibition of work by African Americans.[22] According to Owens, black practitioners fare even worse in the institution's publicly offered seminars on the history of performance art, and even the anthological can only provisionally disturb the operative presumptions on which these narratives are predicated.[23] The implications are as much practical as theoretical. On the one hand, *Anthology* constitutes a response to a legacy of exclusions and holds out the rich array of performative interventions of which black artists are capable; on the other, the project carefully stage-manages a cacophony of voices whose imperatives the artist embodies, travesties, and recasts, sometimes all at once.

Hammons again provides the most telling example. Appearances to the contrary, he was not a willing participant in *Anthology*. In fact, relatively early on in the

19
Schneider, 6, emphasis in original.

20
Finkelpearl, 85–88.

21
Clifford Owens, "Notes on Critical Black U.S. Performance Art and Artists" *HZ* 3 (October 2003), <http://www.hz-journal.org/n3/owens.html>.

22
For a critique of the Museum's attitude toward black artists, specifically women, see Huey Copeland, "In the Wake of the Negress" in *Modern Women: Women Artists at The Museum of Modern Art*, eds. Cornelia Butler and Alexandra Schwartz (New York: Museum of Modern Art, 2010), 480–97.

23
Owens in Stillman, 55.

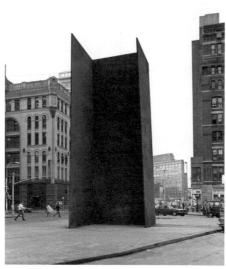

Fig. 5 Richard Serra, *T.W.U.*, 1980, weatherproof
 steel, shown installed at West Broadway
 between Leonard and Franklin Streets, New
 York, 1981–1982. Now at the Deichtorhallen,
 Hamburg. Collection City of Hamburg. Photo:
 Gwen Thomas © 2012 Richard Serra / Artists
 Rights Society (ARS), New York

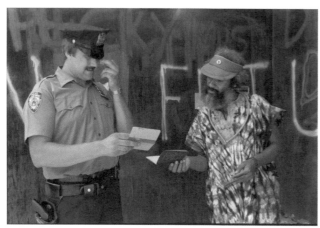

Fig. 6 Dawoud Bey, documentation of *Pissed Off* by David Hammons, 1981.
 © Dawoud Bey

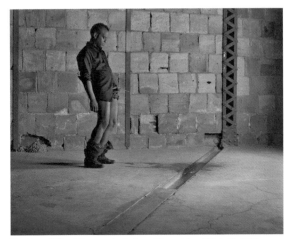

Fig. 7 Clifford Owens, *Anthology (Glenn Ligon)* (detail), 2011.
 3 C-prints, 30 × 40 inches each, courtesy the artist.

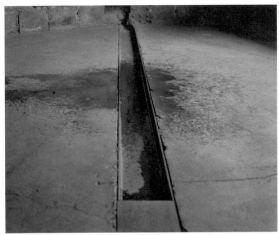

Fig. 8 Clifford Owens, *Anthology (Glenn Ligon)* (detail), 2011.
 3 C-prints, 30 × 40 inches each, courtesy the artist.

project's production, Owens attempted to secure a score from the famously elusive artist to no avail. As luck would have it, Christopher Y. Lew, *Anthology*'s curator, found himself seated next to Hammons at another artist's birthday party. Lew reiterated Owens's request, which Hammons declined repeatedly over the course of the night, each time recasting the grounds of his refusal without any further prompting on the curator's part and thereby providing additional fodder for the younger artist's annotations. Hammons's first, dismissive response, "This is high school," licensed Owens's pissing contest and reframed his own; his second, more considered critique, "There's no tension," laid down a challenge for what the re-enactment should aim to produce. His final parting shot? The verbal equivalent of a pat on the back: "I'm just not feeling it."[24]

In the completed work on view at the museum, *Anthology (Glenn Ligon)*, these three lines, printed in red, surmount a blown-up black-and-white Bey photograph of Hammons's *Pissed Off,* which is sandwiched between Owens's color images of his own performance [page n]. So positioned, Hammons's refusal is both indexed and contained through a selective rendition of the work's coming into being that highlights the interpersonal dynamics so crucial to the art world's functioning yet so rarely countenanced in its histories.[25] More important to Owens's problematic appropriation of Hammons is the evidence offered by the photograph itself, which provides a clear point of visual reference and so clarifies the logic behind *Anthology* as a whole. All too aware of the lapses of memory that plague even recorded black performances, Owens has produced a series of photographs and videos, complete as artworks in and of themselves, that tend to reproduce the look and logic of canonical performance art with its singular focus on the artist's body, but with little of performance theory's worries about "live"-ness, loss, and commodification: these are market-ready objects targeted at History.[26]

To create them, Owens meticulously records each performance, enacting every score multiple times and producing a sea of documentation—never intended for public circulation—from which he carefully selects the footage or photographs that, to his mind, best capture the conceptual tension animating the work.[27] For evidence of this process and its range of outcomes, compare the dramatic stills of Owens performing Dave McKenzie's score, which begins, "Pick a corner of the room and place yourself in it and against it" [Fig. 9], with that of him enacting Senga Nengudi's *Sweep*, a piece that requires the artist to sully the floor with sand before

24
Christopher Y. Lew, conversation with the author, December 16, 2011.

25
Owens is not alone in devising tactical end-runs around Hammons's resistance. I think foremost of the exhibition of the artist's work mounted without his permission by the gallery Triple Candie, a show that featured nothing but printouts and photocopies. See "David Hammons: The Unauthorized Retrospective," 2006, <http://www.triplecandie.org/Archive%202006%20Hammons.html>.

26
On the artist's body as the privileged site of performance, see Coco Fusco, "The Bodies That Were Not Ours: Black Performers, Black Performance" *Nka: Journal of Contemporary African Art* 5 (Fall/Winter 1996): 28. On the importance of live rendition to the genre, see Peggy Phelan, "The Ontology of Performance: Representation without Reproduction" in *Unmarked: The Politics of Performance* (London: Routledge, 2003), 146–66.

27
Clifford Owens, conversation with the author, December 16, 2011.

completing the titular action [page p].[28] The "McKenzie" work is comprised of a suite of pictures, unframed and hung in a corner, that recapitulate the direction and sequencing of Owens's Vito Acconci-style antics in one of MoMA PS1's galleries; the "Nengudi" is a large-format diptych featuring two photographs taken in the institution's basement: one depicts the aftermath of Owens's action and the other shows the artist standing in a pool of light, emptying a sandbag, and channeling the shamanistic energy of a Joseph Beuys.

If the exhibition evokes tried and true roles from the performance-art playbook, then it also smuggles its collaborators, their sensibilities, and a whole host of formal and site-specific antecedents into the frame so that the official record might be re-articulated in light of black artistic practices. In sum, to secure a measure of visibility, the anthologist narrows the range of his own imagistic production and that of the African American performative tradition he is at pains to unearth, putting his faith in the documentary apparatus of the canon and the allure of his carefully conceived pictures. His live renditions, however, open onto other economies—of affect, desire, and bodily engagement—that can only be hinted at by the surface of an image.

Owens's December 17, 2011 performance of *Restating the Image: Construct #10, 1989, Lyle Ashton Harris* provides a case in point [page Z]. The preparatory staging of the score—set up in the interior entranceway of MoMA PS1—presented its own kind of spectacle, a ceaseless to and fro of lighting adjustments, last-minute errands, and quiet joking with the gathering crowd. Once the audience of thirty or so had settled into place and Owens had fortified himself with a beer, he called upon Lew, in his role as the organizer of the exhibition's hanging and performances, to read the score.[29]

"Requirement: Performance is to be performed by Clifford Owens. Once image is shot, Owens is to recite memorized paragraph of scholarly text on the image by Kobena Mercer in front of back drop."[30] Following the beat of his own drummer, Owens began by posing questions about Harris's work and offhandedly tossing out 11×17-inch color copies of the eponymous black-and-white photograph. In it the older artist sports a black bobbed wig, a rolled-up tank top, and a white tutu as he stares directly out at the viewer, his arms akimbo, his genitals exposed, and his legs twisted into an elegant *contrapposto* [Fig. 10].

In line with Harris's original picture, the focal point of Owens's *mise-en-scène* was a simple studio set-up comprised of tungsten lamps and a long backdrop—now deep pink rather than velvety black—hung from above and extending onto the floor. Rather than insert himself into this scenario, at the outset Owens put his audience to work: each individual who responded to one of his queries—What is this photograph about? Do you identify as a gay man?—was asked to step onto the backdrop and to assume the pose so that Owens might remake the picture. In this way, the artist contravened Harris's instructions and the conventions of his private studio

28
For the complete scores of the McKenzie and Nengudi works, see pages I and P, respectively, of the present volume.

29
Christopher Y. Lew, email to the author, April 18, 2012.

30
The Mercer excerpts were to be derived from the essays "Black Masculinity and the Sexual Politics of Race" and "Dark & Lovely: Black Gay Image-Making" in *Welcome to the Jungle: New Positions in Black Cultural Studies* (New York: Routledge, 1994), 131, 222, 230–32.

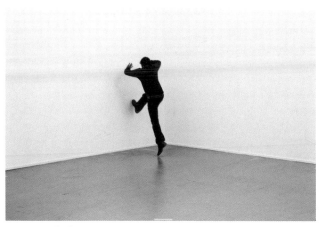

Fig. 9 Clifford Owens, *Anthology (Dave McKenzie)* (detail), 2011.
15 C-prints, 16 × 20 inches, courtesy the artist.

self-portrait session in order to produce a dialogic theater for the assumption of an image, the revelation and affirmation of gay male identities, and a running commentary on the public unfolding of both.

Throughout this initial phase, Owens's tone was undeniably charming and vaguely coercive. His banter became more critical as the performance wore on, leading him to question the assumptions undergirding Harris's work and his re-enactment of it. "What happened to the critical moment of the 1990s of identity politics? What's changed other than there being an asshole black President?" Soon enough, half-serious quips morphed into solicitous confessions: "I can't make images about representation anymore, it just doesn't matter.... I love to fail publicly.... Tell me what I need to do to re-stage this image."

Through such signifyin' asides, Owens at once parodied and ventriloquized a presumed art-world common sense about the limitations of Harris's art, which can read as earnestly confrontational when compared to the messy evasions of a younger black queer practitioner like Kalup Linzy.[31] While Harris has been one of a handful of black figures included in widely read volumes on performance art, his work, and that of many artists who emerged in the context of late 1980s multiculturalism, has usually been positioned in terms of "identity," rendering it vulnerable to charges of formal underdevelopment and social overdetermination despite assertions to the contrary by scholars like Mercer.[32] What the score demanded, then, and what the performance allowed was not so much Harris's inclusion within an anthology but a rescripting of the terms of his work's discursive appearance.

Enter the artist in question. Harris, seated in the audience for the duration of the performance, took the opportunity afforded by a break in Owens's monologue to vocally rearticulate his directive: "Just do the score!" Despite his apparent resistances—he never did recite those paragraphs—Owens handed over the camera to Harris and quickly got naked, joking that the audience had no need to be terrified of him, since this was one black man whose penis was neither gargantuan nor tantalizingly hidden from view. With contributions from the audience, he began to suit himself up, donning lipstick, face powder, a black bra, and an array of scarves around his waist [page z]. His props in place, Owens announced, "I feel it now," and began striking the imaged stance, which, he admitted, was far from a physically easy or emotionally neutral feat: Harris's photograph demands a measured admixture of mimicry and disarticulation, defiance and seduction.[33] As he aimed to perfect the pose with the guidance of the audience—now quite familiar with Harris and his *Construct*—Owens, holding back tears, commented on how such a bodily disposition

31
Tavia Nyong'o, "Brown Punk: Kalup Linzy's Musical Anticipations" *TDR: The Drama Review* 54.3 (Fall 2010): 71–86.

32
For the relevant discussions of Harris's work, see Amelia Jones, *Body Art: Performing the Subject* (Minneapolis: University of Minnesota Press, 1998), 215–220; and Tracey Warr, ed., *The Artist's Body* (London: Phaidon Press Limited, 2000), 155. For a key example of the critical dissensus around so-called multicultural practices, see Hal Foster, Rosalind Krauss, Silvia Kolbowski, Miwon Kwon, and Benjamin Buchloh, "The Politics of the Signifier: A Conversation on the Whitney Biennial" *October* 66 (Fall 1993): 3–27.

33
On the psychosexual and sociohistorical implications of the pose, see Craig Owens, "Posing" in *Beyond Recognition: Representation, Power, and Culture*, eds. Scott Bryson, Barbara Kruger, Lynne Tillmann, and Jane Weinstock (Berkeley: University of California Press, 1994), 201–17.

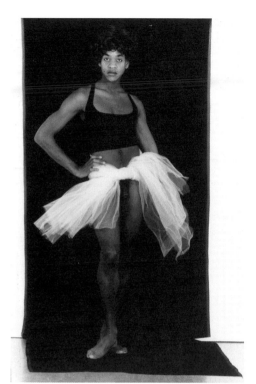

Fig. 10 Lyle Ashton Harris, *Construct #10*, 1989. Black-
and-white mural print, 72 × 36 inches, courtesy
the artist and CRG Gallery, NY.

recalled that of his own queer family members, uncles and cousins, who died of AIDS-related complications.

These reflections, in their turn, led to another affective shift and a further solicitation of the audience: having framed Harris's work as a bodily performance of black gay subjectivities under threat of extinction, Owens asked that everyone present who knew someone who had died of AIDS join him before the backdrop, creating a portrait of individuals left standing in the wake of the epidemic's first brutal wave in the US. In its participatory structure and emotional ambition, the performance resonated with Owens's ongoing series *Photographs with an Audience*—variously enacted in New York (2008); Chapel Hill, North Carolina (2009); Houston, Texas (2011); and Miami, Florida (2011)—in which the audience, at times nude along with the artist, becomes the subject of the performance and its imaging [Fig. 12].[34] In these works and in the live version of *Anthology (Lyle Ashton Harris)*, the artist enjoins his spectators in the construction of a public in a move away from what Kathy O'Dell defines as the social contract of performance and toward what Ariella Azoulay terms the "civil contract of photography," each represented body made visible as the author of claims to history, citizenship, and their mutually constitutive boundaries in the imagistic field.[35]

With my eyewitness account of this performance in view—itself a trace that might otherwise fall out of the anthologist's scope—the ends of this essay are now in sight.[36] For if Owens's differing engagements with Hammons (by way of Ligon) and Harris (by way of audience) emphasize the centrality of the image to histories of black performance art, then they also provide further insight into the particular problems faced by African American practitioners in the present, which are hyperbolized, even exacerbated, by *Anthology*'s structure. Meaning, to recall Owens's declaration, is in crisis, particularly for contemporary black artists intent on making critical interventions without a political field or a discursive framework to call their own.

Arguably, this was not always the case. Coco Fusco contends that, historically, the medium of photography and the genre of performance art, which so often privilege the nude body, have posed inherent difficulties to African American artists given the production of black subjects as the loci of the camera's often violent, criminalizing gaze and of slavery's infernal processes of corporeal objectification.[37] In *Pissed Off* and *Construct #10*, Hammons and Harris scandalously repudiate such impositions,

34
Valerie Cassel Oliver, "Clifford Owens: Some Questions" in *Perspectives 173: Clifford Owens* (Houston: Contemporary Arts Museum Houston, 2011), 6. For a particularly compelling account of the Houston performance, see Hank Hancock, "Getting Naked with Clifford Owens at CAMH" *Houston Press*, January 7, 2011, <http://blogs.houstonpress.com/artattack/2011/01/clifford_owens.php/>.

35
Kathy O'Dell, *Contract with the Skin: Masochism, Performance Art, and the 1970s* (Minneapolis: University of Minnesota Press, 1998); Ariella Azoulay, *The Civil Contract of Photography* (New York: Zone Books, 2008).

36
While Owens executed a photographic work based on this performance not long before this essay went to press—see page bb—he effectively blocked any documentation of the live rendition other than his own, whether personal or institutional. According to Lew, at present, "there are no plans for the project to enter the MoMA collection," a fact which again raises the question of *Anthology*'s eventual fate within the archive, a concern anticipated by the artist Lorraine O'Grady. Her score—printed in full on page AA of the present volume—ends with the following request: "Send a (low-res, low-tech, low-value) copy of this record of interaction to Lorraine O'Grady for her archive." Christopher Y. Lew, email to the author, April 3, 2012.

37
Fusco, 28–33.

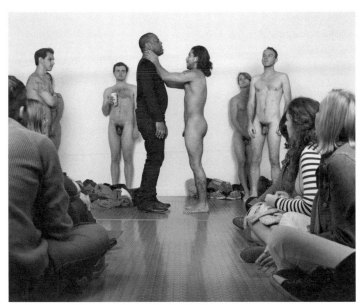

Fig. 12 Clifford Owens, *Photographs with an Audience (Houston) (Choke)*, 2011.
C-print, 30 × 40 inches, courtesy the artist.

the former with his clandestine urination, and the latter with his confrontational stare. By contrast, when Owens stripped down at MoMA PS1, there was little of the anxiety that has long accompanied the sight of the nude black male body: this was simply an artist in an institution putting on the standard performative suit.[38]

The same might be said of the photograph that records Owens's performance—in dark shades and an actual black suit—of Rico Gatson's score *Five Minutes*, which calls for a rehearsal of the Black Power salute raised by John Carlos and Tommie Smith at the 1968 Mexico City Olympics.[39] The resulting work, however, gains its charge less from the current political relevance of the gesture and more from its restaging within the frame of James Turrell's permanent 1986 MoMA PS1 installation, *Meeting* [page t]. Like Serra's trough, this work is a cut into the building's roof, yet rather than orienting viewers toward the ground, its precisely delineated opening turns them toward the heavens, thereby allowing *Anthology (Rico Gatson)* to read as a new model of transcendence. Here and elsewhere, *Anthology* suggests that there are no longer any radical moves to be made, injunctions to be refused, or criteria to be rejected other than the poses provided by a host of antecedents, whose performances, when masterfully or half-heartedly re-staged, just might manage to make some claim on the present and its grounds of articulation. In Owens's work, these grounds can only be fleetingly located, if not secured, by the photographic image and the subjects who appear within it.

This is not, I think, merely a symptom of his art or of its emergence within a post-black, post-Obama, post-Performa world. Rather, it is an effect of a larger transformation in the Western public sphere occasioned by the expansion of the neoliberal capitalist enterprise and its attendant destabilization of meaning since the 1980s. As critical theorist Lauren Berlant has argued, in this milieu, neither citizenship nor its emotional valences are surely intelligible, leading subjects to delegate affects and ideologies to others so that their impact might be viewed, evaluated, and assimilated at a subjective remove, strategies entirely in line with the logic of outsourcing that drives the contemporary service economy.[40] This set of conditions speaks well both to *Anthology*'s rampant contradictions and its provisional achievement: nowadays, it would seem, the best bet is to photograph everything and to mount the most resonant images on the wall in the hopes that some histories will stick, some feeling will come through.

38
Fusco offers a useful genealogy of these dynamics (see p. 29)—particularly in her discussion of the furor generated by Robbie McCauley's 1990 nude performance at the Studio Museum in Harlem—which might be extended to construct a genealogy of nude African American performance that includes the work of less well known artists such as Sherman Fleming in addition to those practitioners discussed here.

39
The full score reads: "Is inspired by the 1968 Olympics medal ceremony where Tommie Smith and John Carlos accept the gold and bronze medal in the 200 meters while giving the black power salute. My score is for Cliff to interpret the scene/moment as he sees fit dressed or not also according to his desires. The desired duration of the piece would be five minutes." For a snapshot of contemporary artists' deployment of such figures, see Jeffrey D. Grove, *After 1968: Contemporary Artists and the Civil Rights Legacy* (Atlanta: High Museum of Art, 2008).

40
Lauren Berlant, "Structures of Unfeeling: *Mysterious Skin*" public lecture, George Washington University, March 30, 2012. Berlant's analysis relies on Slavoj Žižek, "The Interpassive Subject" *Traverses* 1998, <http://www.egs.edu/faculty/zizek/zizek-the-interpassive-subject.html/>. For analyses of the relation between contemporary performance art and the larger service economy, see Schneider, 137, and Claire Bishop, "Outsourcing Authenticity? Delegated Performance in Contemporary Art" in *Double Agent*, eds. Claire Bishop and Silvia Tramontana (London: Institute of Contemporary Arts, 2008), 110–25.

Re-stage, Recite, Repose, Regret:
Clifford Owens and the Performance of History

John P. Bowles

Many of the artists Clifford Owens invited to write scores for him to perform in *Anthology* provided instructions for him to address the past, sometimes by attempting to reenact it and other times by assuming an attitude of reflection. The scores— written by more than twenty artists representing several generations, from Fluxus of the late 1950s to some of Owens's younger contemporaries—invoke a range of past events and figures, named and unnamed, including James Weldon Johnson's "Black National Anthem" (1900); jazz pianist and composer Bud Powell; LeRoi Jones's play, *Dutchman* (1964); Yvonne Rainer's *Trio A* (1966) and her many subsequent representations of it; Tommie Smith's and John Carlos's Black Power fists, raised at the 1968 Olympics; Richard Serra's *Hand Catching Lead* (1968); Public Enemy; Marlon Riggs; Lyle Ashton Harris's *Construct #10* (1989); Carrie Mae Weems; P-Diddy's participation in an advertising campaign for Proactiv anti-acne facial cleansers, and Lil Wayne's hip-hop recordings. Despite the variety of allusions and references, one figure recurs throughout the performances and resulting photographs: Clifford Owens, working within and against the guidance the scores provide.

In the exhibition, Owens presents each of the executed scores alongside photographs and/or video works that represent his attempt to perform it. However, because the still and moving images offer only a suggestion of each performance, viewers cannot be sure of the outcome: was Owens somehow able to reconnect with the legacy of the scores' authors, who, considered collectively, suggest a complex history of African American performance artists—a history Owens appears to claim? If an anthology is a selection of texts that represents a movement, tendency, or discourse, then the importance of the history *Anthology* represents is implicit.

Significantly, in *Anthology*, Owens does not re-stage historically important performances. Instead, he invited artists to write him new scores and, generously, the participating artists reciprocated by providing them. As if repaying a debt to those who prepared the way for him, Owens refuses to relegate the participating artists to the past but reminds viewers that all of them are alive and active, not simply as historical figures but as an imagined community of mentors, role models, and colleagues.[1] Has Owens invited artists who made some of their most widely known work years or even decades ago in an attempt—or perhaps as a performance of the attempt—to recapture or relive the very history *Anthology* attempts to bring into being?[2] Is each score a surrogate for a history Owens regrets he was never a part of, and each performance a display of the artist's wish to retroactively insinuate himself into it?

[1]

Some of the artists Owens invited to write scores for him attended *Anthology* performances and Owens also curated a program (at MoMA PS1 on March 11, 2012) for which he invited some of the artists to present performances of their own. Nevertheless, it is difficult for visitors to *Anthology* to know how closely Owens has worked with any of the participating artists.

[2]

Several recent exhibitions have attempted to establish similar histories. Some of the most important include Naomi Beckwith's *30 Seconds off an Inch* at the Studio Museum in Harlem (2009), *Now Dig This! Art and Black Los Angeles 1960-1980* at the Hammer Museum of Art (2011), and Valerie Cassel Oliver's *Radical Presence: Black Performance in Contemporary Art* at the Contemporary Arts Museum Houston (2012).

With *Anthology*, Owens does not simply offer a historical survey or a celebration of a legacy he can claim. Instead, he enacts a critique of history and of the desire to be part of it. By inviting his predecessors to participate, Owens identifies himself with them. Many of the scores instruct Owens, in his performance, to assume a particular attitude toward the past: to memorize, invert, answer, or synch with various events (to draw on words from the scores). Although the concept of an anthology implies a representative sampling, the scores compel Owens to do more than reminisce about familiar, supposedly seminal performances. They also require him to acknowledge and engage with a variety of sometimes unrelated episodes from the past, some personal, some widely known, and others apparently insignificant or largely forgotten. Owens's *Anthology* is not a survey or a coherent narrative of African American performance art. Instead, he performs the work of the genealogist, whom Michel Foucault tasks with "liberating a profusion of lost events" that challenge the idea of a common identity or experience by describing our varied origins and "numberless beginnings."[3] Rather than identify with or claim an under-recognized history, Owens enacts a need to try out varied subject positions by attempting to inhabit them. Foucault warns of the risk genealogists take by refusing to satisfy themselves with the reassuring comforts of a clear history and coherent identity: "destruction of the subject who seeks knowledge in the endless deployment of the will to knowledge."[4] In other words, the genealogist seeks the possibly untenable opposite of the self-satisfied claim to a particular identity. Thus, Owens animates *Anthology* not by affirming a history of African American performance art but through his repeated attempts to inhabit it by annotating, interpreting, restating, and mimicking the irretrievable past (to use more words from the scores).

Anthology gathers well-known African American performance artists in a common project, as if to reunite a super-group that broke up years ago. However, most of the artists who contributed scores to the project have never worked together. Rather, Owens's choice of artists strikes us as logical due to conventions of art history that justify grouping them together in retrospect and as representative of various histories of performance art. The reunion Owens has imagined for us draws upon the feelings of loss we experience when viewing documentation of performance art. Documentation of previous performances (or of artworks that present themselves as some form of documentation) will often stir in us the wish to have seen them firsthand. Douglas Crimp has written that in the turn to performance art, artists drew on lessons from minimalism and conceptualism to create artworks that implied "literally that you had to be there," a shift that emphasized the experience of the "spectator in front of the work."[5] As a result, when we look at scores or photographs of performances, confronted by indexical evidence of artworks we never experienced, we feel our own absence from the work.

This experience is heightened in photographs that include the audience. For example, Owens exhibits one work consisting of three photographs of his

3
Michel Foucault, "Nietzsche, Genealogy, History," trans. Donald F. Bouchard and Sherry Simon, in *The Foucault Reader*, ed. Paul Rabinow (New York: Pantheon Books, 1984), 81.

4
Foucault, "Nietzsche, Genealogy, History," 97.

5
Douglas Crimp, *On the Museum's Ruins* (Cambridge: The MIT Press, 1993), 109.

performance of Maren Hassinger's *Repose* [see page c]. In two of the photographs, Owens's limp and naked body appears in the center of the composition, which has been cropped so that the artist is surrounded by the legs and arms of participants who hold him awkwardly. In the third photograph, Owens lies on the floor while the legs of several people, whose upper bodies have been cropped out of the composition, line the back wall, as if standing by, uncertain about how to respond to the motionless figure before them. Looking at the photographs, we feel removed from the actions photographed. I was present for this performance but, examining the photographs, I feel as though I can no longer recall whether I witnessed these events or had them described to me. For the performance, curator Christopher Y. Lew read each position described in the score and then the participants struggled to arrange Owens's passive body into the pose described: "Position 1: Sitting straight up, your back near the wall to the left of the main door and your legs straight out on the floor in front of you, arms relaxed on either side of your legs. It could be a day at the beach and the sand would be warming your legs." Hassinger's score draws upon my memories of the beach, but the effect of the photographs is contrary, estranging me from my own memories.

Owens, like many performance artists, has embraced the careful use of photography to make the point that while the photograph can stand alone as an artwork, those of us who were not "there" when the photograph was taken will necessarily understand the work differently than anyone who was. A corollary lesson is that, faced with the photographic evidence, events will never appear the same again. This confirms Allan Kaprow's insistence that by scoring photography into his Happenings, he might heighten the experience of recalling performance through rumor and gossip while also making viewers aware of how little the photographs revealed about events they purported to document.[6]

The effect is so compelling that, even when the photographs capture a performance we have attended, the resulting image can appear strange. This is my experience of photographs Owens made of his two performances of *Photographs with an Audience* at the University of North Carolina at Chapel Hill (2009). In each example, the people photographed appear carefully arranged before the camera, sometimes symmetrically; in other cases, against the rules of successful picture-taking, they are positioned so that some participants who stood closer to the camera loom giant-sized over the others. Standing stiffly, looking straight ahead into the camera's lens, everyone in the photograph is aware that he or she is being photographed. Yet the logic of each composition is a mystery. My memory is that each photograph represents an answer to a question Owens asked the audience, such as "Who here has ever loved a black person?" (To be honest, I cannot even recall the questions precisely. This is simply an example to the best of my recollection). To answer affirmatively, participants stood before the audience and the cameras (one digital, one Polaroid). Sometimes, Owens rearranged the participants; sometimes he stood among them; then he instructed the photographer to take a picture. I held the exposed Polaroids, timed them, and peeled away the covers. The chemistry among the participants one night was like the last night of summer camp, as though we were bound to each other, awkward for the brevity of our intimacy; the second night, the audience turned cautious

6
I discuss performance artists' calculated use of photography in my book, *Adrian Piper: Race, Gender, and Embodiment* (Durham, NC: Duke University Press, 2011), 197-204.

and wary. Almost nothing of my experience comes across in the photographs. I recognize some of the faces or clothes, I know the room, but the logic behind each photograph is lost. Are these the same performances in which I took part?

Prior to *Anthology*, Owens embarked on some of his own attempts to reimagine seminal performances as if to acknowledge the fact that viewers of scores and photographs from past performances must take creative liberties to make sense of them. In *Anthology*, Owens takes a different approach. Rather than recreate or revise other artists' performances, he has reached out to artists who were "there" and who made some of the most familiar artworks we never saw by inviting them to write new scores he can perform. Owens makes a gesture of recovery, as if to salvage or revisit bygone eras: the international flowering of Fluxus in the late 1950s and into the '60s; the following decade's charged crucibles of Feminist, Black Arts, and performance art movements in Southern California; "the 1980s." This seemingly attempts the impossible, but Owens has built into his project acknowledgment of the futility of recapturing the urgency of earlier events. Instead, the urgency of *Anthology* is of a new generation; it is a desire Owens shares with his audience to take responsibility for history.

Several scores take loss as an organizing principle and Owens, in the attempt to follow through, performs the dilemma of melancholia. For example, some scores instruct Owens to internalize the process, as in Steffani Jemison's *Regret Piece*: "Experience regret. Do not apologize." Others are more specific, as in the case of Glenn Ligon's untitled instructions to "Annotate an existing performance/score. Perform that performance annotated" [page N]. The example given by Ligon is of one performer reflecting on her own past work: "Yvonne Rainer dancing 'Trio A' while telling the audience what she is feeling as she is doing it, what moves she can't do because she is older, etc." In this case, Rainer redeems her loss (her ability to enact the moves she can no longer perform) in a new work, something entirely original that is not a pale version of the earlier piece, but draws upon its significance to Rainer, to histories of performance art and modern dance, to the avant-garde [Fig. 1]. What the authors of these scores grasp is the melancholic undercurrent in Owens's *Anthology* project.

"Repetition creates bliss," the enigmatic epigram for Shinique Smith's score [page W], invokes the pleasure that melancholia promises. Melancholia, as Sigmund Freud describes it, establishes or grasps hold of an instance of loss that the subject internalizes as an organizing principle. This constitutive mechanism is a response to a loss so fundamental that it threatens to change the subject's world profoundly and therefore cannot be acknowledged. As a result, the subject internalizes the object of the loss, nurturing it within the psyche in a desperate attempt to sustain the viability of both object and subject. Melancholia results from the subject's ultimate dissatisfaction with the ego as substitute for the object it cannot acknowledge having lost. Following a circular logic, to compensate, the subject continues to turn inward, performing what Judith Butler has described as an engrossing and "compensatory form of negative narcissism."[7] The subject must continually attempt to conceal the loss from him- or herself by enacting melancholic ambivalence toward what has been lost. *Anthology* seems premised on such a process: Owens invites his predecessors

7

Judith Butler, *The Psychic Life of Power: Theories in Subjection* (Stanford: Stanford University Press, 1997), 182.

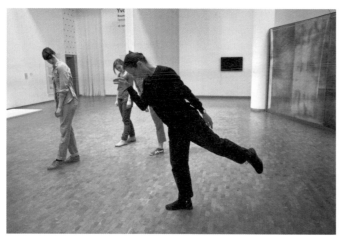

Fig. 1 Yvonne Rainer, documentation of a rehearsal of *Trio A*, 1973, as a part of
Yvonne Rainer: Raum, Koerper, Sprache at Museum Ludwig, April 28–July
29, 2012, Cologne, Germany, video still. Image by AnkeSchwarzer.de.

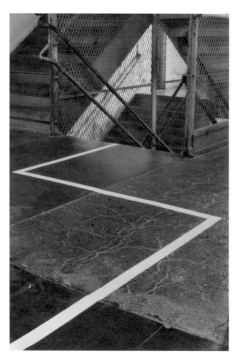

Fig. 2 Clifford Owens, *Anthology (William Pope.L)*
(detail), 2011. 20 archival pigment prints,
13 ½ × 9 or 9 × 13 ½ inches each, courtesy the
artist.

to engage with him through new work that he will perform, acknowledging the futility of revisiting a past that has long since passed while simultaneously insisting on its viability as a legacy, influence, or inheritance that can be (re-)enacted. The *Anthology* scores serve as supplements, standing in for the history Owens addresses, and as compensation for having missed it.

Anthology comprises Owens's attempts to address history by taking responsibility for it. He expresses admiration for the participating artists by generously inviting them to contribute and when they reciprocate by providing him with scores, Owens acknowledges these, in turn, by performing them. Nevertheless, he also articulates a degree of apprehension in performance. It is as if, faced with his absence from the countless events that comprise his history of African American performance artists, he has invited those who were "there" to assist in writing him into their history. At the same time, Owens performs a dilemma familiar to many of his peers: how to acknowledge previous generations of African American artists who articulated a range of critical approaches to the question of "race" without reifying the problematic concept of "race" in the process. Historically, African American artists have almost always found themselves trapped in this double bind: viewers expect their work to represent African American culture and, as a consequence, too often turn a blind eye to the possibility that the work might represent anything else. Artists who are African American inevitably find their work interpreted according to viewers' assumptions about race. In response, some have developed critical strategies that anticipate viewers' needs, making artworks that remain obdurately inscrutable, a foil for unfulfilled fantasies of race. Others perform the double bind to expose it, perhaps making it available for critique. This seems the point of William Pope.L's untitled score: "Be African-American. Be very African-American" [Fig. 2]. Is it possible to distinguish this piece from any other Owens performed for *Anthology*? That is the dilemma with which Pope.L confronts both artist and audience. The result, at its best, is not a refusal to engage but a thoughtful and considered approach to putting the viewer's anticipation on display.

For example, while Owens pays homage to African American artists throughout the exhibition, in some artworks Owens addresses a broader history of performance art. The photographs he made to represent Derrick Adams's score, *"How to Preserve Your Sexy" borrowed from the words of P-Diddy "And You'll Need a Hand Towel,"* seem to trace an intergenerational lineage nearly a century long [Fig. 3]. In addition to the references in the title, Adams's score is a simple list of three facial-care products made by Avalon Organics, each of which he identifies by name along with directions for use quoted from the bottle, package size, and price [page J]. Owens exhibits photographs alongside Adams's score that capture participants in mid-performance with what looks like soap suds on their faces and in their hair. The visual reference is not to P-Diddy (who in 2006 participated in Proactiv's promotional campaign for a similar line of anti-acne products) but to at least three artworks: Owens's photographs resemble both Man Ray's 1924 photographs of Marcel Duchamp with shaving cream on his face and in his hair (which Duchamp used for his *Monte Carlo Bond* of that same year) [Fig. 4] and Ana Mendieta's untitled color slides (1972) representing the artist with what looks like her shampooed hair arranged across her face and sculpted

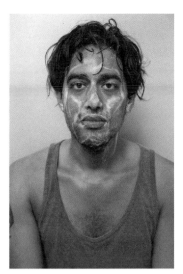

Fig. 3 Clifford Owens, *Anthology
 (Derrick Adams)* (detail), 2011.
 31 C-prints, 10 × 8 inches each,
 courtesy the artist.

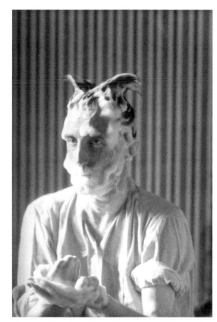

Fig. 4 Man Ray, *Marcel Duchamp, 1924*, gelatin
 silver print, 3 ³⁄₁₆ × 2 ¼ inches. © Man Ray
 Trust/ADAGP-ARS/Telimage — 2012

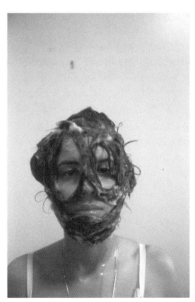

Fig. 5 Ana Mendieta, documentation of
 an untitled work, 1972. Iowa, 35mm
 color slides. © The Estate of Ana
 Mendieta Collection. Courtesy
 Galerie Lelong, New York

into whimsical hairdos, an artwork scholar Julia Herzberg calls a "theatrical reenact-ment" of the Duchamp photographs [Fig. 5].[8] More recently, Owens attended Ben Patterson's 2011 *Please Wash Your Face*, for which Patterson invited members of the audience to participate in a performance of public face-washing, an event to which Owens alludes, in turn, by involving others in completing Adams's score. In *"How to Preserve Your Sexy,"* Owens draws upon a history of artistic collaboration and inter-generational dialogue to "preserve" several seemingly disparate legacies by demon-strating their continuing relevance.

"Pick a corner of the room and place yourself in it and against it.
"Try to conjure up a past that isn't your own."[9]

Owens displays a grid of fifteen color photographs arranged in a corner beside Dave McKenzie's score but offers no explanation [page i]. Owens looks uneasy in the first photograph: tightly pressed into a corner, apparently alone, dressed in black, he looks small, diminished by the blank white walls that confine him [Fig. 6]. The arrangement of the photographs implies a sequence of actions. However, Owens has left gaps to signal to viewers that the performance the photographs purport to document is no longer available. Instead, viewers must "conjure up" the events photography cannot capture. The verb, "to conjure up," suggests a thought process that is less methodical than the historian's but also less personal than memory. To conjure is to invoke the intervention of others—spirits or ancestors, perhaps—and to leave oneself open to fate. Various African American artists have used the term to suggest cultural traditions of the African diaspora, from Romare Bearden's *Conjur Woman* collages (1964), to the ways in which Betye and Alison Saar describe their artistic processes, to the term's more circumspect use by Kara Walker and Whitfield Lovell.[10] In *Anthology*, Owens seems to conjure up various African American per-formance artists who came before him, artistic ancestors (as well as several of his younger contemporaries), inviting them to prepare scores for him. In the process, Owens invites them to help reconstruct a history of African American performance art. However, what viewers experience is not only evidence of Owens's attempts to address history. In Owens's performance of conjuring up a past that isn't his own, viewers are provoked to take responsibility for the result. As McKenzie's score instructs, "Stop! Now think about a future after you."

8
On Marcel Duchamp's use of the Man Ray photographs, see David Joselit, "Marcel Duchamp's *Monte Carlo Bond Machine*" *October* 59 (Winter 1992): 8–26. See also *Man Ray: Photography and its Double*, eds. Emmanuelle de l'Ecotais and Alain Sayag (Corte Madera, CA: Gingko Press, 1998), 257. For Ana Mendieta's photographs, see Julia P. Herzberg, "Ana Mendieta: The Formative Years" *Art Nexus* 47 (January–March 2003): 56. See also Olga Viso, *Unseen Mendieta: The Unpublished Works of Ana Mendieta* (Munich: Prestel, 2008), 24–27.

9
See page I for entire score by Dave McKenzie.

10
For example, see Kara Walker's *Night Conjure* (mixed media and paper on board, 2001) from her series, *American Primitives*. See also Whitfield Lovell, "Op-Art: The Dream Described" the *New York Times* (January 18, 2010).

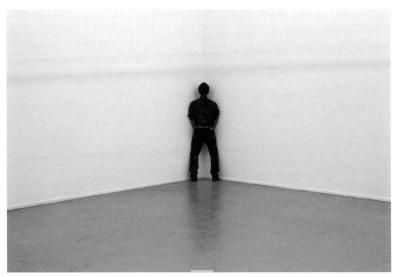

Fig. 6 Clifford Owens, *Anthology (Dave McKenzie)* (detail), 2011. 15 C-prints, 16 × 20 inches each, courtesy the artist.

Trust Me: *Anthology* from One Perspective
Christopher Y. Lew

Anthology responds to a gap in art history that Clifford Owens has contemplated for a decade. Since his graduate studies at Rutgers University, Owens has recognized that there was no in-depth analysis of performance art made by African Americans. There was no doubt that such work existed—even before he began to create *Anthology*, Owens's practice made pointed references to his artistic forerunners. His answer to this art-historical void is not an academic text, but a body of work that is deeply personal, subjective, and heartfelt. A number of the artists Owens invited to participate in *Anthology* are pioneers in the field of performance, while others are better known for their object-based work. Regardless of their practices, over the course of the project, Owens has deepened his relationship with all of them. Those whom Owens initially respected from afar have become trusted confidants, long-term relationships have grown emotionally and intellectually richer, former students are now emerging in their own right, and participants who have insisted on maintaining their distance have continued to challenge Owens to raise the bar.

From late May through September 2011, Owens set an exhaustive pace for himself at MoMA PS1 to enact the performance scores contributed by twenty-six artists. Though Owens was not able to create final video, photographic, or audio works from every score in time for the exhibition's opening that fall, he did accomplish his largest project to date, one that points forward and backward to other generations, toward other ways of looking and doing, and to legacies that can no longer remain on the dusty shelf of the archive or studio. All this was conducted over four months and was compounded by a difficult period in Owens's personal life.

In light of this, I cannot pretend my role in *Anthology* was always that of the critical curator or producer. At Owens's insistence, I became a supporting player in the live performances, corralling the audience—in my mind as the reluctant MC—and then as a kind of narrator, reading each performance score aloud before he enacted it. I would much rather stay behind the scenes organizing the events than perform before an audience. Aside from the fact that there was no one else to read the scores at that first performance in May, it is due to Owens's trust and belief in me and in the project that I took on this role. The process of *Anthology* stems from mutual trust and belief, not only between one artist and curator, but also trust and belief among twenty-seven artists, trust and belief that one's writing and action can alter the arc and bend of history.

Risk

From the audience's perspective, anything can happen in Owens's live performances—audience members are invited to talk back, to step to the fore and interact with the artist or each other; food and objects are thrown about; articles of clothing are removed or exchanged; physical violence is implied; rape and autocastration threatened.

What prevents Owens's performances from dissolving into chaos is not his per-suasive charisma and cunning, but the conceptual parameters of the work. The often-simple premises he establishes—to invite someone into the studio, to follow the instructions given by audience members or fellow artists, to make pictures with a group of people—have laid the foundation for a range of possibilities and subse-quent outcomes.

Highlighting the human body, and especially the artist's body, Owens's perfor-mances stem from the legacy of body art that began in the late 1960s. In particular, Owens's work is aligned with performances that are stubbornly grounded in their literalness and that reject theatricality. Vito Acconci's *Following Piece* (1969), for which Acconci selected an individual at random and followed that person until he or she entered a building or otherwise left the public street,[1] and Marina Abramović's *Rhythm 0* (1974), in which the artist presented a tabletop with seventy-two objects that could be used on her by the audience in any way,[2] are just two examples. In both, the respective artist has largely relinquished control and allowed others to wit-tingly or unwittingly determine the course of the work. The parameters of the per-formance are determined before it begins and the artist is not actively directing the course of the event.

In 2005, as part of the *Greater New York* exhibition at MoMA PS1 (then known as P.S.1 Contemporary Art Center), Owens presented *Tell Me What To Do With Myself* [Fig. 1 and 2]. In a small room on the second floor, he built a wall to separate himself from the audience. Visitors could instruct Owens to perform actions by speaking into a microphone. Obscured by the wall, the audience could only see him through a peephole located close to the floor or on a closed circuit monitor. Owens relin-quished the decision-making power to the audience/viewer. The viewer seemingly had total freedom and control over the situation—any command could be relayed to the artist for him to perform.

Risk is inherent in the performance. Former P.S.1 curator Amy Smith-Stewart recalls that museum administrators were "very worried about what the audience would tell him to do."[3] Looking back at the project, Owens further elaborated, "It revealed who people were. People don't necessarily honor the contract or presumed agreement that 'I will do no harm to you,' 'I will treat you humanely,'—and won't tell you to lick up your own piss or jerk off."[4] Ultimately, Owens became an agent in his own work, acting out the fantasies of the audience. He became a foil for the group's collective imagination while the individual audience members—physically separated from Owens—performed for each other by giving commands.

As a set of instructions to enact, the most well-known performance scores are likely associated with Allan Kaprow's Happenings, which began in the late 1950s, and Fluxus, the international movement coordinated by George Maciunas, starting

1
Frazer Ward, "In Private and Public" in *Vito Acconci*, eds. Franzer Ward, Mark C. Taylor, and Jennifer Bloomer (New York: Phaidon Press Inc., 2002), 38–40.

2
Klaus Biesenbach, *Marina Abramović: The Artist is Present*, (New York: The Museum of Modern Art, 2010), 74–79.

3
Amy Smith-Stewart, conversation with the author, February 27, 2012.

4
Clifford Owens and Christopher Y. Lew, "Conversation Piece" *North Drive Press* #5 (2010).

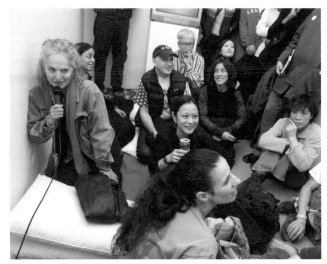

Fig. 1 Clifford Owens, *Tell Me What to Do with Myself*, 2005. C-print, 16 × 20 inches, courtesy the artist.

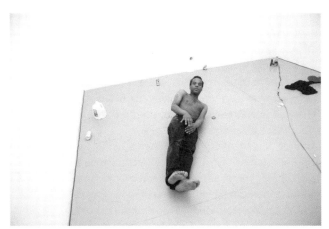

Fig. 2 Clifford Owens, *Tell Me What to Do with Myself*, 2005. C-print, 16 × 20 inches, courtesy the artist.

in 1961. The *Anthology* performance scores contributed by fellow artists prescribe the actions to be taken by Owens. However, he has been careful to distance himself from the Dada sensibilities of Happenings and the ironic wit of Fluxus. More than once, he has said Fluxus is "about jokes and *Anthology* is not about jokes."[5]

As a whole, the *Anthology* project further tests the agency of the artist. Some specific scores, like those by Kara Walker or Jacolby Satterwhite, put demands on the performer to an extreme degree, the former to demand sex from an audience member and the latter to spend twenty-four hours with a fellow black male artist. For a notable group of performances—based on scores by Sanford Biggers, Maren Hassinger, and Steffani Jemison—Owens empowers the audience and welcomes their active participation in order to "fulfill" the demands of the scores. In the intro-duction to the performance of Hassenger's score, *Repose*, Owens says, "I need your help to complete this score." Lying nude, face down to the floor, he explains that he cannot perform this score alone, that he needs the audience to help place his body into the five positions described by Hassinger [page C]. Written in a narrative style that alludes to the body in landscape, the score details five positions of rest, vary-ing from seated poses to prone. For each position he asks a certain number of men and/or women in the room—ranging from one person to four women to everyone present—to help place his body. Owens is limp, corpse-like, throughout the per-formance. During the MoMA PS1 performances the participants listened to the instructions phrase by phrase and conferred among themselves on where in the room his body should be oriented and how it is to be placed.

During the enactment of Hassinger's score, the audience members often treated Owens's body with great tenderness. Though there were moments when he would be carelessly dragged about, participants were generally careful to a level of deep poignancy. In the March 11, 2012 performance, a sole participant was positioning Owens when he realized Owens was oriented 180 degrees in the wrong direction. He slid his own body behind Owens's, as if spooning the artist, and rotated together on the floor like a pinwheel until both of them were in the correct position. There were moments of humor as well, when participants would carry Owens back and forth, shuttling him from one wall to another, unable to interpret the instructions correctly, as the rest of the audience offered advice.

The final video of the work depicts the performance from a vantage point unavail-able to the audience or performer [page c]. Shot from overhead, Owens knew his body would be obscured by the participants as they huddled over him, touching and moving his body. The participants were then instructed to step back, presenting the artist's body to the camera. Over the course of the five positions, Owens was covered by others, revealed, and carried across the frame. For the Western viewer, it is difficult not to read the actions through a religious lens; the handling of Owens's limp body is reminiscent of paintings of Christ's descent from the cross. Depicted by count-less artists over centuries, including Raphael, Caravaggio, Rubens, and Rembrandt, Christ's body is often presented stark and limp, held in the arms of numerous figures.

The preparation and manipulation of the body is also notable in Owens's *Studio Visit* series (2004–06), especially the works that involve Carolee Schneemann [Fig. 3] and Joan Jonas [Fig. 4]. Initiated when Owens was a resident at Skowhegan (2004)

5
One instance was during Owens's conversation with the Yale MFA photography class at MoMA PS1, February 21, 2012.

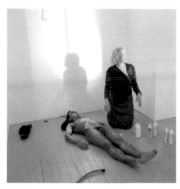

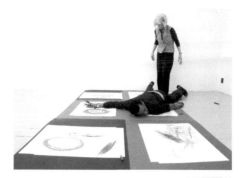

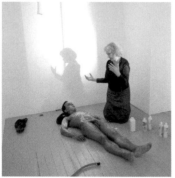

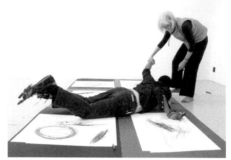

Fig. 4 Clifford Owens, *Studio Visits: Studio Museum in Harlem (Joan Jonas)*, 2005. 2 C-prints, 25 × 30 inches each, courtesy the artist.

Fig. 3 Clifford Owens, *Studio Visits: Carolee Schneemann*, 2006. C-print (diptych), overall: 30 × 25 inches, courtesy the artist.

and continued during his residency at the Studio Museum in Harlem (2005–06), Owens played on the traditional studio visit by inviting other artists and curators to his studio to conduct collaborative actions. Each visit was designed with the particular visitor in mind. Schneemann was invited to massage Owens's nude body and moisturize it with lotion, in homage to her groundbreaking work involving the body, sexuality, and cultural taboo. Alluding to Joan Jonas's videos that foreground the act of drawing within performance, Owens asked her to tape graphite to his hands and feet, and to drag his body over large sheets of paper to make drawings. Describing the series, Owens says, "I entered into a kind of social contract with each visitor by surrendering my body to someone else's will."[6] Reflecting on her *Studio Visit*, Schneemann presciently writes, "Where black performance artists are so often marginalized and obscured, Owens's project effortlessly merged all of these suppressed issues: not only race, but gender, age, and history."[7]

Still

The gap between the performance score and live enactment is twinned by the space between the performance and exhibited works. Owens has always resisted calling the final images documentation. Instead, the live actions become a means to generate photographs and videos. At the beginning of the first performance of *Photographs with an Audience* (2008) in New York [Fig. 5], Owens explicitly said to the audience, "This is not a performance. This a way to make pictures together."[8] This statement was implicit in the *Anthology* performances as well. It was always apparent that the live performances were to be photographed and videotaped—lighting equipment and cameras were prominent in the space. The transparency of the mechanics and the final aim to produce images is important to him. Furthermore, during the live events, Owens would speak freely to the camera operators, asking them if he was still in the frame, if they metered for the exposure, and other technical questions. Speaking about his process at large, Owens said the "performances are the conditions under which the photos are created."[9] He clearly performs for the camera as much as the audience.

Owens is acutely aware of how a still photograph can become the symbolic stand-in for an entire performance. He has repeatedly said that the history of performance art is just one history of photography, meaning that most people learn of specific performances not through direct experience but through still images disseminated by publications and other means. In his essay "The Performativity of

6
Lauren Rosati, "Lauren Rosati on *Studio Visits*" in *Performa: New Visual Art Performance*, ed. RoseLee Goldberg (New York: Performa, 2007), 157. It is worth noting for his *Studio Visit* with Patty Chang, the two artists attempted to re-perform Vito Acconi's *Pryings* (1971). Owens said, "What we did was not about romantic nostalgia, but continuing the conversation about performance art." (*Performa*, 155). The connection to body art of the 1960s and '70s has been a long term interest for the artist.

7
Carolee Schneemann, "Carolee Schneemann on *Studio Visits*" *Performa* 157.

8
Clifford Owens, conversation with the author, April 4, 2012.

9
Clifford Owens, private presentation to the Contemporary and Modern Art Perspectives group at The Museum of Modern Art, April 4, 2012.

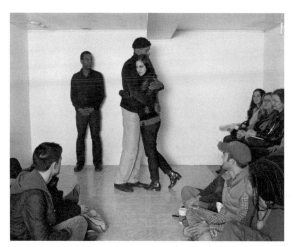

Fig. 5 Clifford Owens, *Photographs with an Audience (New York)*
(detail), 2008–09. 18 C-prints, 16 × 20 inches each, courtesy
the artist.

Performance Documentation," Philip Auslander insightfully examines how a photograph can function, in and of itself, as performance. Whether the work was performed before an audience, made alone in the studio, or is a composite of multiple images does not determine if it is or is not a performance piece. Auslander says the criteria "is its framing as performance through the performative act of documenting it as such."[10] It is the intentionality of the image that frames it as a performance. From this standpoint, to argue whether or not an image is documentation becomes moot. The distinction becomes less relevant when the images are responsible to a different audience, not the one attending the live event, but the audience as viewer of the image. In Owens's images, as in many iconic images of performance art, the audience is not depicted. The viewer of the image becomes the audience of the performance, bringing the past event into a continuous present.

For one example, the final work from Nsenga A. Knight's score, *Come Clean*, is a photographic diptych, one large-scale print hung above the other [pages A and a]. Owens decided to do the reverse of what the score prescribed. Rather than clean a space, he decided to dirty the MoMA PS1 conference room by exploding a helium balloon filled with a concoction of dust collected from the museum and baby powder. This was one of the rare instances where the performance was enacted solely for the camera. The resulting images are the only traces of the action—the dust and powder suspended in mid-air in one photograph and covering the artist and floor in the other. In the diptych the action is at once occurring and complete, with Owens staring directly at the lens of the camera, directly at the viewer of the image, implicating the beholder.

Once

Lyle Ashton Harris had submitted his score in September 2011, two months before the *Anthology* exhibition would open. At that time Owens was busy with selecting the final photographs to be printed, mounted, and framed, in addition to editing the hours of video he had amassed. The performance of Harris's score (pages Z and z) would not take place until after the exhibition opened. Leading up to the performance, Owens was worried about how to conduct the performance, how the act of "restating the image" Harris had made in 1989 could be done as a compelling live action. A photo shoot was a structure and situation Owens had utilized in the past. I suggested he borrow the framework of his *Photographs with an Audience* series (2008–ongoing) to perform Harris's score. In *Photographs with an Audience*, the making of images became the crux of the performance. The audience was an active participant, at once subject and actor, nearly on par with the artist. In a similar way, the pretext of a photo shoot would provide an entry point into the score, allowing Owens to engage with Harris's polemical photograph *Construct #10* (1989) [page 27, Fig. 10] and bring the audience in dialogue with it.

December 17, 2011: the audience gathered at MoMA PS1 to experience the performance of the score, including Harris himself. A medium-format camera sat on a tripod, flanked by two strobe lights facing a bright-red seamless backdrop. The

10
Philip Auslander, "The Performativity of Performance Documentation" *PAJ: A Journal of Performance and Art* 84.3 (2006): 7.

seamless was unrolled to an exaggerated length, running well past the camera and lights, covering the stretch of the room. Owens entered and began to fling copies of Harris's original image into the audience. He asked who in the audience knew the photograph and who wanted to speak about it. One man volunteered and Owens asked him to stand before the camera and interpret the picture. Owens made a photograph as the man spoke about identity and sexuality. Others stepped forward and contributed to the discussion. Owens then stood before the camera and attempted to assume Harris's pose as the audience shouted ways to better mimic the original. Owens began to explain how he did not want to wear a wig and tutu, saying it made him feel like a minstrel and entertainer. He stripped nude, pulled out a pocket knife and pointed it towards his genitals while speaking about castration. Harris grew visibly frustrated. "Just do the score," Harris yelled from the back of the room. Owens became livid, though he complied. He asked the audience for items of clothing that would help create the image. Scarves were tied around his waist, someone offered a puffy hat to stand in for a wig, one woman applied lipstick to his lips and another loaned him her bra. Owens instructed Harris to operate the camera and make photographs as each article was applied. Unexpectedly, Harris personified the insistence of the performance score. Owens could not get off easy by talking around the subject of the score. It had to be confronted, dealt with directly if it was to be resolved.

Again

Kara Walker's score was one of the most difficult sets of instructions to realize. At one level, the score functions as a concise summary of the exigencies of Walker's own art. Sex, violence, and power in America are mined in her wall installations and animations. Owens was compelled to work out and resolve the score on his own terms. He had to find a way to "French kiss an audience member" and "demand sex," which was simultaneously disquieting and morally responsible (page R). The initial performances of the score created an atmosphere thick with tension, but little action. No one was willing to participate, to fulfill the demands of Walker's text.[11] The subsequent enactments of the score at the museum engaged those issues not as metaphor or allusion but on a more literal and brutal level. As a black man making advances upon an often largely white audience, Owens situates the work within deeply rooted American anxieties. Reviewing one performance, Marissa Perel writes, "we were all participating in some kind of exorcism by recapitulating the shared trauma of slavery and prejudice."[12] This anxiety, and, I dare say, hysteria were sensationalized by one writer who suggested an actual forced sex act would take place at Owens's final MoMA PS1 performance.[13] Through the simple act of entering into the

11
For a more detailed outline of the early performances of the score see my article "Kiss & Tell: The Process of Performance Art" *Huffington Post*, November 18, 2011.

12
Marissa Perel, "Gimme Shelter Smash Your Idols: Clifford Owens at MoMA PS1" *Art 21* blog, December 29, 2011. <http://blog.art21.org/2011/12/29/gimme-shelter-smash-your-idols-clifford-owens-at-moma-ps1/>.

13
Rozalia Jovanovic, "Will Clifford Owens 'Force a Sex Act' on His Audience at MOMA PS1 on Sunday?" *Gallerist NY*, March 8, 2012. <http://www.galleristny.com/2012/03/will-clifford-owens-force-a-sex-act-on-his-audience-at-ps1-on-sunday/>.

personal space of individual audience members—staring, touching, and sometimes kissing—Owens has been able to suggest the horrific acts and powers society has projected upon the black male body.

On an occasion of amazing synergy, Walker made a surprise appearance for the final performance, collaborating with Owens to enact an extended version of her score (page R). Like Harris commanding Owens to "just do the score," Walker highlighted the duplicitous nature of the instructions. She shadowed Owens as he stalked the room, like a kind of witness to the coming violence. He said to her, "I'm doing this for you. I'm doing this for you, Kara," emphasizing his role as agent, highlighting all the sinister connotations of just following orders.

Leading up to this performance, Owens said he was "going to take it *there*" (my emphasis).[14] Where *there* is can easily be misconstrued as a place of actual violence, especially when that place is seemingly unknown, somewhere Owens is in the process of finding through live action and the involvement of an audience. During Owens's most powerful and engaging performances, *there* is not a place of fantasy or the imagination, but a place of difficulty, fear, and anxiety that opens into a site of confrontation and recognition. The process has involved not only audience members, but also the artists who originated the scores, as well as this curator and institution. Owens needs all of our help to get *there*, a place where we arrive together.

14
Ibid.

Bernard Lumpkin in conversation with Adrienne Edwards

Adrienne

I often refer to Cliff's performance technique as the "Cliff treatment," which is to say that it is a complex methodology that pivots on interrelated and interdependent axes such as vulnerability, trust, seduction, and power. What was the first live performance you saw of Cliff's and tell me what struck you most about the piece? Do these pivot points relate to your experience?

Bernard

I first saw Cliff's work at P.S.1 for the 2005 *Greater New York* show. It was the piece *Tell Me What To Do With Myself*, where he sat in a room and people wrote instructions and commands for him. It made a big impression on me because it was the first time I'd seen an artist put him/herself out there in that way, taking all kinds of risks—physical, psychological, emotional—in the process. But the risks not only applied to the artist. Implicit in the performance was the message that looking at art shouldn't always be something easy and free and passive. Art can make demands on you, it can exact a payment from you (in a good sense) in return for the pleasure it provides. That payment, in Cliff's case, is participation. My other early memory of Cliff's work—the collaborative piece he did with Xaviera Simmons, with the whipped cream[1]—deepened my understanding of what that participation means. Cliff doesn't so much coerce his audience as seduce them. Thanks to his irresistible mixture of charm, guile, and persuasion, Cliff makes you *want* to help him make the work, and to sign on to the often scary and always revelatory journey that defines his performance practice. It made me appreciate the seductive power of Cliff's work. In this case the audience member was another artist—which only gave me more respect for him.

Adrienne

Can you speak more about the interactive nature of Cliff's performances?

Bernard

Every Clifford Owens performance involves ritual and romance. [For *Anthology*] he starts by eyeing the crowd: walking back and forth down the room. There's a lot of swagger in that walk. He's sizing people up and getting a feel for the room. He's testing the waters and measuring the vibes. In these opening minutes, he gets a sense of the individuals who will in the next moment become his collaborators and co-conspirators. But first, there's the seduction. Zooming in on his chosen few, he circles closer and closer to engage and entice. He is quiet, watchful, aware. The tension is broken only by his command to the curator to repeat the score—once, twice, three times. This call and response becomes a prelude to the drama, a kind of foreplay. The repetition of the score becomes a chant, an incantation, a call to action.

Adrienne

For me, one of the most striking aspects of *Anthology* is its relationship to performance and art-historical genealogy and history. With this project, Cliff has created an intergenerational archive of performance by black artists and his peers who are working today, as well as a repertoire of black performance for himself, other artists, and generations to come. What are your thoughts about the importance of this project in this regard?

Bernard

Anthology suggests the canon, safe-keeping, immortality, whereas performance art is by its nature fleeting and ephemeral. I was excited when Thomas Lax

1
Clifford Owens's 2006 performance *Four Fluxus Scores by Benjamin Patterson* at the Studio Museum in Harlem.

proposed *Anthology (William Pope.L)* to us on the Acquisition Committee at the Studio Museum because it's a piece which captures the art-historical dimension of Cliff's work. Through *Anthology* Cliff is helping to bring new attention to a generation of African American performance artists whose work has not been adequately recognized and appreciated. The piece belongs in the Studio Museum's collection both because it's an excellent example of Cliff's work and because it pays homage to Pope.L, whose work has influenced Cliff and countless other artists. Cliff not only embraces the performance-art tradition within which he is working—aside from William Pope.L, it also includes Vito Acconci, Carolee Schneeman, and Lorraine O'Grady—but he exploits it to positive effect in his own work. Museums play a critical role in helping the public understand the development and trajectory of art within specific genres; one can only fully appreciate Cliff's brand of performance art in the context of other black performance artists like Pope.L. This educational component is intrinsic to the idea of an "anthology"— like the *Norton Anthology of English Literature*. Thanks to the pedagogical dimension of his work, Cliff is as much a teacher as he is an artist.

Speaking of Cliff-as-teacher, I sat in on the performance art course he taught at the Yale School of Art. It was the first time a course on performance was offered at Yale. His students adored him and—as evidenced by the final performance projects, which he invited me to come see—they had clearly learned a lot from him. Though these students had only worked with him for one semester, the "Cliff Owens effect" was on full display in their work!

Adrienne

Which *Anthology* scores have been the least successful?

Bernard

The only scores which I would deem "unsuccessful" are the ones in which the audience doesn't participate—especially out of fear or ignorance. Nevertheless, I feel that Cliff's work wouldn't have the same power were it not for the ever-present tension, discomfort, and very real potential for failure one feels whenever he takes the stage. Even when a performance isn't "fulfilled" or "completed" it is still in my view successful because what matters most is the journey that the performance involves, and not necessarily its fulfillment. In this way, Cliff's work is always hopeful, always optimistic. It's a promise! It requires faith!

Lanka Tattersall and Elaine Carberry in conversation with Thomas J. Lax

Thomas
How would you describe Clifford's style of performance?

Elaine
Range-y. He definitely switched several times, moved through different ways of staging being a man. He would be "Low Self-Esteem Man," or "Really Sweet Nice Guy," or "Oh you think I'm aggressive, don't you?"—he would aggressively say that, then be kind of defensive about it. And he would also just simply follow the script and its prompts. He also had moments of very much playing the role of "Performance Artist," and be thoroughly vulnerable in that way—really wanting an audience's reaction, and also an applause or a laugh.

Thomas
Lanka, can you talk about the performance that you were a part of?

Lanka
When I walked in that day, I think the first thing I noticed was that Cliff has a really strong energy pull. I was like, "Wow, okay." I think it was partially because he was in this performance moment, and also because he was in the middle of kicking a hole in the wall, so I was like, "Okay, I'm ready!" But there's also this question of authentic feeling, and was this a performance gesture? What was the authentic feeling behind what was going on, and how constructed was it? Chris [Lew] would read the score, and I remember the language of the score was really beautiful and it had kind of this hypnotic, prescriptive sound to it. Even if I don't remember exactly what it said, I had this feeling like, "Okay, how does this kicking a hole in the wall relate to the score?"—not really knowing how things were going to connect.

Thomas
Can you talk about Clifford's engagement with the audience?

Lanka
There was one time when he was having people take pictures with their cellphones, which felt a little silly (laughs).

Elaine
Crowd-pleaser?

Lanka
(Laughs) Yeah, like a crowd-pleasing thing, because I think people weren't participating so he was trying to find easy ways for people to become participants. I mean, it did the trick. Everyone was like, "Oh, I know how to take a picture," and "I was at this crazy PS1 performance and this angry guy was punching holes in the wall, and then I got on stage and it was so New York!" This is what I was imagining people were feeling.

Thomas
How is Clifford interested in the medium of performance? He relies on photography and video, but is equally invested in narrating a history of something specific to "performance art." And also, is he successful at narrating this history? What is its relationship to art history? Is it successful as art? And if history is an important term here, I think it's important to historically situate Clifford's emergence. He was in *Freestyle*, which was the first show at the Studio Museum in Harlem in which Thelma Golden articulated the idea of post-blackness. Clifford's work emerges in the wake of identity politics in the '90s, during which many artists were unfairly characterized as abandoning form for

content. How much of Clifford's work is about form, and how much of this is about content?

Lanka

I think that form and success relate in interesting ways. In terms of the form question, something that I think is really strong in the project is more how the documentation was presented when the exhibition went up. One thing I noticed is how many different modes of documentation there are and how he is this totally different person from one piece to the next or—perhaps more to the point—how he presents himself as this totally different person from one piece to the next. This actually plays to the question of authenticity. You get the sense that in Kara [Walker]'s piece, for example, he is actually playing, taking on, or exaggerating a kind of aggressive side, versus in that really beautiful piece where he does the model-artist collaboration, then it's this whole other kind of identity. I think that's really successful in the form of the later exhibition. That multiplicity thing that he's doing I think actually really speaks to being in this moment, where the form is mutability of presentation.

Thomas

Let's talk more about the Kara Walker score. The three of us have spent time thinking through questions of sexual violence and its relationship to desire in several contexts. Can you talk about how some of those issues played out here?

Lanka

In the performance context, I just feel bad for people. I think it manipulates people and probably disregards people in the audience who may have had experiences around rape; especially if you walk in and you don't know what the score is, and then you hear the score and you're like, "This is a really uncomfortable situation for me." But what are your options?

Elaine

To speak to what you are saying about the constant negotiations: I don't know if everyone in the audience shared this, but I know that the three of us talked about having a running commentary in our heads in which we are constantly negotiating desire—once you are inside the door, every moment renegotiates consent. You're saying to yourself, "If he calls me I'm going to say no. But what does it mean if I say no?" You're writing an essay in your head, thinking through all the various responses to each moment and deciding who you want to be right now. In terms of people who have experiences with rape—

Lanka

Or even who haven't.

Elaine

Exactly! Because that's everybody: we all experience and negotiate consent and rape all the time. And the thing about consent and rape is that they are so flimsy as notions—it's difficult to think through them. Even in talking about consent, you have to build a few walls and just look at a skeleton of a building to try to get at it. It's really not a solid thing to talk about. There's not a substantive thing that is consent—there's just the frame, just all these feelings around this notion. So it kind of collapses when you push on it, but you know that it's there, and that you're feeling a lot of things around it.

Thomas

We've spoken about notions of authenticity, and the slipperiness of determining what is a performance and what is not. We've also talked about the way ideas of performance extend from an artistic context and impact differently-raced and differently-gendered bodies. In other words, how queer and femme folks are read as performative and excessive. To

use your words, Elaine, how some people are marked as performances before they enter into a space. Can you both talk about how notions of femininity and notions of black masculinity play out in Clifford's performance—art-historically and interpersonally?

Lanka

Well one way to think about this—if I put on my art-historical glasses—is what is the actual historical lineage for a project like this? It could go two different ways: one would be World's Fair displays of blackness, and this idea of being on display, and being in a context that's already set with a stereotype. But the other way would be like Chris Burden getting shot in the gallery and charting a lineage of these situations with risk. I think with Chris Burden he was not actually supposed to be shot but he was, so there's that route. So I'm just trying to construct the lineage of black performance that would speak to that.

If anything, there does seem to be a gap that this performance is articulating—a kind of identity that, at least to me (and I'm not an expert at all), has never been articulated through performance in the way he's doing it. So even with the question of failure, I think of course the project is set up to be awkward and failure-y and he's setting himself up for moments where he is humiliated.

I guess that's the weird thing about producing something in a vacuum where you can see what the vacuum is shaped like, so you know the contours of what that performance has to be. In that sense, *Anthology* is really successful at actually articulating that space—but it's just unfortunate that people have to feel so uncomfortable and awkward. But that's reality, you know, and I think that's actually where performance can be really powerful.

Thomas

Can you talk about the dynamic between Cliff and curator Chris Lew?

Elaine

I remember that Clifford and Chris had shaved their heads in similar ways the night before the performance, so they both had exactly the same haircut.

Lanka

Oh, that's why they both had that haircut. Which is totally like an aggressive *Taxi Driver*, "I've got a gun" haircut (*laughs*).

Elaine

(*Laughs*) Yeah, they were looking badass—but also cute in that way because they had done that together. I was so charmed by that.

Lanka

Their matching haircuts?

Elaine

Yes—they were like, "Look, we did this. Samesies!"

Elaine

That was actually one of my favorite features of the entire performance: to watch Cliff and Chris's dynamic. You rarely get to see that, and watch that—the relationship between an artist and the curator of his show.

Lanka

Yeah, that was what made me feel okay. In some ways it kept me okay. I was like well, they have their connection.

Elaine

I know, and it was very endearing! I was completely charmed. That's a moment that they're bringing in, something that happened the previous night, when we weren't there. I felt like, "This is genuine you, and I like you, so regardless of what happens, I'm going to be with you

throughout this." There's a sense of trust that's set up in that way. And also just their sizes—he's bigger than Chris...they were just a sweet pair. You know what I mean?

Lanka

They are a sweet pair, definitely.

Kate Scherer in conversation with Thomas J. Lax

Thomas
Can you describe what your role has been in working with Cliff?

Kate
I was Cliff's production manager for all the performances.

Thomas
Where in that process would you fit in?

Kate
During the summer, he performed several times a week—more than twenty-five performance dates. He often worked through ideas conversationally, so we spent a lot of time talking in his studio at PS1. Some performances required more unusual elements, like a live chicken or a certain beer only available in his hometown of Baltimore or a group of kids to sing the Black National Anthem in the museum. For the [Benjamin] Patterson score, he wanted the audience to hoist him to the rooftop tower with a rope. Cliff was always interested in pushing his limits as a performer and audience expectations for engagement. Watching a performance, you could often feel him not knowing exactly how he would shape it, then sense the shift when a direction or solution came to him. Moments that, as an audience member, made you feel very present and part of the work.

Thomas
Since you've been involved so closely, can you talk about his working method? What happened leading up to each performance?

Kate
For Cliff, conversation is a form of sketching. So there's a relationship between the performances and his working process which incorporates interaction and exchange with many different people and ideas. There was always the interesting problem of how to plan for a performance while also preserving a pocket of unknowability that was necessary for the performance to work. I often thought of his performances as machines for intimacy where certain structures could be set up, then broken, as a way of making contact.

Thomas
Is who you experience Cliff to be in those conversations and moments similar to the Cliff of the performances?

Kate
There are some similarities: the framing of the self, his statements, how they hang in the air. They are elements that he is very conscious of, and he is able to convey them casually. Also, he floats provocative ideas as prompts or starting points—little laboratories to take a human temperature.

Thomas
Having attended a number of them, I noticed that Cliff's performances are very process-based. From one performance to the next, the same score would result in different actions. How were these versions or variations from your perspective?

Kate
The score that evolved the most through repeat performance was the [Kara] Walker. I don't know if you were there for the first iteration in May—nothing happened.

Thomas
Nothing at all happened? I don't think I was there for that one. Can you describe it?

Kate

The Walker score instructs him to
assume the role of a sexual aggressor,
and his initial response was to invert that
directive. He stood in the middle of the
room while Chris [Lew] read the score.
Instead of approaching people, Cliff asked
the audience to come to him, and when
no one did, Chris continued to repeat
the instruction over and over. It became
very tense. If either Cliff or a participant
had acted, the consequence of all this
potential would have had a fixed shape
that could be responded to. Instead,
irresolution was the outcome. But also
empathy, from what we had all silently,
un-innocently speculated together. That
was the only time the Walker score was
performed like this. After that, he took on
more active roles within the instructions
of the score.

Thomas

What were elements of the performances
that you consider unsuccessful? As
somebody who was able to calibrate
success in very real terms, but also as
somebody that's obviously very interested
in the possibilities and potentials of
performance as a way of thinking through
ideas, what were things that you thought
didn't work? And I ask you this partially
from Cliff, who's very interested in ideas
of failure.

Kate

Something that became apparent as the
project progressed and gained attention
was the impact of a large audience. We
are less vulnerable as part of a crowd.
So the size of the audience affects the
exchange—the kind of casual conversa-
tion that makes Cliff's performances
powerful and uncomfortable and able to
elicit a range of feelings over the course
of twenty minutes.

But mostly, I go back to the Kara
Walker score. The time that it "failed" was
in my mind its most successful version.

Gabriela "Gabi" Scopazzi in conversation with Adrienne Edwards

Adrienne

How was Lorraine O'Grady's score introduced to you?

Gabi

Well, first Cliff and I had a pre-meeting the day before the performance to make sure I was comfortable with the situation, because I knew I was going to be nude at my workplace [MoMA PS1]—which is I guess a little of an uncomfortable gesture, but I was fine with it. And then after we had that conversation to make sure I was alright with everything, he did read me the score. I kept that in the back of my head, but not very consciously.

Adrienne

Tell me what happened in the performance. What do you recall about it? Where did it take place?

Gabi

It was the same exact space as Cliff's studio. In the first performance, there wasn't so much space for either of us to get that close to the camera. So it was more like a full-body experience. It also might have been a little strange for the audience, because of the way it was set up. There was a live feed to this larger room where people could sit and watch. Because of the setup, we didn't interact with them. It was a completely separate space. We didn't address the fact that it was live. It could have been pre-taped, and then just shown—which wouldn't have made a difference in the first performance. In the second performance, Cliff walked out into the audience, engaged with them, saying maybe not the most serious stuff, like "Oh look at that!" or stuff of that nature.

Adrienne

Was the chicken in the first one?

Gabi

Yeah. The chicken was always there. But in the second performance, in the third part when he interacts with the various fruits and vegetables, that section resonated with me. When he stuck his dick in the eggplant, and then started cutting it. He didn't do that in the first one. I felt like I was on an emotional rollercoaster, which I think is really important in viewing something that's live. It could have went really *bad*, he could have really seriously hurt himself. But everyone became *alive*; seeing that energy in a room, being in that room, while it's happening. There are no other words to describe it. My heart was racing. I'm like, "Oh my God, he's really gonna hurt himself." 'Cause I know that he will keep on going until he feels in his heart that he needs to stop.

Adrienne

So then you guys were doing a series of what I call "still acts." Almost kind of like a *tableau vivant* or a series of these improvised, restrained movements. Tell me how you thought about the movement, how you and Cliff came to those movements.

Gabi

In our first conversation, before any of the performances happened, he was saying "Tell me to do anything. I have full trust in you." I think he said something like if I said to poke his own eye, he would have done it. Or take a shit. He's like, "I would have done it" *(laughs)*. So that was a preface to everything. We got some mobility in the actions—there wasn't any specific thing that I had in mind, it was more like I said something, maybe it was something like, "Go on the floor and try to touch your toes," and then having seen that, something—I

wanted it to be very organic. It's all intuitive.

Adrienne

What did you think about the presence of sexuality in the work? We've mentioned the chicken and we've talked about the fruit. What do you think about your particular section, as it relates to sexuality?

Gabi

Well, just having two naked bodies is obviously going to bring up that conversation. But I don't think it was overly sexual. Maybe sexual in this dominatrix-type of way? Of him telling me what to do, maybe in that aspect? But even when he was touching me, it wasn't really that sexual. Since we were trying to be this otherness, I didn't even really define us as people or humans. I don't know what to call us. We were just this other, like exactly what the score calls for—to be this otherness in which we over-shined emotion, in which we just were in the space enacting actions. We were actions; that's what we were. And then having said that, the actions maybe were sexual; maybe when I was touching my breast and then going up to the camera. Maybe it was sexual for the audience, but I didn't feel any sexuality because it wasn't my brain trying to enact that. It was Cliff telling me to do that. So yes, I was physically rubbing my nipple, but I wasn't feeling it physically, and I wasn't feeling it emotionally.

Matthew McNulty in conversation with Thomas J. Lax

Thomas

Once you started going to the performances at MoMA PS1, what were some of the surprises? What were some of your immediate reactions? What did you think overall based on your assumptions of what it would be?

Matthew

The first time I went, Cliff did the Maren Hassinger piece first, and I'll never forget walking in and seeing him. From what I heard about the previous performances, he would come in from the office naked, which I think is pretty abrasive. When you walk in, he's face down on the floor, naked. Everybody just files in and sits around, so this kind of creates the space, or the "walls" as he puts it. Everybody files in and sits along the wall—the actual walls—and then he looks at you and says, "I need your help on this one." So that was my first memory. I was like, "Okay, I get this."

Thomas

Do you think that this is something that anybody can enter into? Do you think that Cliff is making a space that, regardless of your relationship to contemporary art, your relationship to performance art, or your relationship to art by artists of African decent, anybody can enter into? Or do you feel that in the same way that you can feel pushed away by MoMA PS1, you might also feel pushed away because you are not part of this community that already exists?

Matthew

So what role does PS1 play in the audience's interpretation? If you look at the pictures you don't know where they were taken, so it's really just the time and place that matters. I think he got over that by taking us around the building,

which is what I really liked about the most recent performance I attended. It was the first one where I got to see a performance in a hallway, and then go into the boardroom—we're going to do something there. I remember when I saw him walk in with the balloons and I was standing right next to him, I was like, "Shit, I'm going to get dirty." Knowing where the room was and everything, the building became a lot less sterile, so PS1 in a sense became a lot less sterile for me.

Thomas

So what you're suggesting is that you could have been to none of the other performances and you still could have had the same kind of feeling of community, intimacy, and the breaking down of barriers, despite the fact that this was the first time you were introduced to it, because of the way that Cliff reorganizes the space, the way he makes the space more playful, or the way he makes certain spaces that are not necessarily for art-viewing into performance spaces?

Matthew

Yeah, and it's also his presentation of the work. I love it when he'll stop and say, "Do you know?..." He wants to make sure that everyone is on the same page. He'll stop the performance and say, "Do you have the shot framed?" which shows that his post-performance work, meaning the pictures and everything, is as important as the performance itself.

Thomas

How many times did you see the Kara Walker interpretation?

Matthew

I saw the first one where everybody was on the floor, and then I saw the one at the bonus performance.

Thomas

Okay, let's start ground up. Can you

describe the first performance, and then describe the second one.

Matthew

Well it was funny because I didn't really know him, and it was my first [*Anthology* performance]. Was that the June 25th [2011] one? Yeah, that was my first foray into it. So we're sitting there, we see him toss a box around, and then he brings on the new one. And you're sitting there, and he had already thrown the beers out into the crowd and I didn't have a beer, and I was sitting there and he's like, "Okay, cool, this is what we are going to do. Somebody has to come up here, you have to come to me." Then he started to walk around the room, and that's when it occurred to me that he could approach somebody and I guess it could be anybody.

Thomas

So at first you thought he might not approach anybody?

Matthew

I never thought he wouldn't approach anybody, but the big thing was that I may be involved beyond where I wanted to be involved. I think I was sitting in the back row. He yelled out, "What are you guys all afraid of?" and somebody yelled out, "The lights!" so he turned off the lights. It got extremely quiet, no one was moving. Then I started to hear someone shuffling, walked up, and then they threw the lights on for a second, took a picture, and threw them off. He did it with two people, and that was it. Coming out of that performance I didn't really think about it a whole lot. I was hung up on the idea that he didn't carry out the whole score. I was hung up on that for a long time.

Thomas

What about that kept your attention?

Matthew

Well the fact that the person was

supposed to turn the tables, or Cliff was supposed to turn the tables on the person, and the person was supposed to come to us for help. So I kept thinking, well how would that play out? How would we help this person? How theatrical would it get? How real would it be? I was kind of lost in how far he could push that aspect of the score. Otherwise, I'm pretty visually familiar with Kara's work, so the score didn't surprise me at all.

Thomas

Coming from her?

Matthew

Yeah. The second time I saw it, which was when everybody was lined up, was when I realized that he could come up to me. I didn't hear about the first one where everybody was lined up when he went up to a guy. At this point I knew him, but there was about a ten-second period where he stared right at me. Then he came and he went to the person next to me, which was great.

Thomas

What were you thinking for those ten seconds?

Matthew

I had no idea how I responded when he came up to me. Having been to a bunch of performances, you don't want to disrupt everything, but I certainly didn't want to be making out with him.

Thomas

But he did end up making out with you?

Matthew

No, he went to the person next to me. So I got a nice front row seat of how it goes down.

Thomas

And what was your experience of being a viewer in that very participatory moment?

Matthew

Well that was cool. The one with every-body on the walls was cool because you could see the tension as he enters your space, and you can see it in the video. I think the video in the museum is edited perfectly because you can see when people give up their guard. It reminds me of that girl in the video, the blonde girl in the corner, she kind of gives up her guard and is like, "Okay, I'm ready," and then he walks away. So it's cool to see the interaction get forced, bubble over, and either hit or he just walks away from it. That was the most audience-specific comfort zone that was pushed around.

Thomas

So in terms of the way that could play out based off of the audience, do you feel like your experience is shaped by your understanding of yourself as a man? Do you think it would be different if Kara was performing it? Or if Cliff was performing it and you were a woman? Or if you were a woman and you were one of his students, for example?

Matthew

How would I see it then? Would I feel brutalized?

Thomas

Yeah, for example.

Matthew

I guess. But you have the option to leave. And he does give you the option. Chris [Lew] reads the score, whether Cliff's going to perform it or not, he reads the score out so you know that the tables could turn at any second. So if you get involved, or if he steps into your space... I don't know, I guess if I was a woman I'd definitely be a lot more nervous, because he kissed a lot more women than he did men.

Thomas

So the odds are stacked against you, in a sense?

Matthew

Yeah. I don't know if I can really think about it from that perspective because I am a guy, and now I know Cliff. If I had been in that situation the first time, I probably would have been a lot more nervous.

Thomas

The situation of him coming that close to you, not knowing him?

Matthew

Yeah. But I don't know if I would have felt brutalized. I don't know...

Ryan Inouye in conversation with Thomas J. Lax

Thomas

Can you speak about the structure of Cliff's performances and his interpretations of the performance scores?

Ryan

Cliff interprets the scores as a kind of a sequence of transcriptions. Having a background in literature, I often think really linguistically, so those are the metaphors that come to mind. I thought the whole structure that Chris [Lew] and Cliff set up was super interesting, this idea of inviting other artists who think performatively to develop a score to give to Cliff, to then enact before an audience. I think there is this series of transfers that happens to create this interesting structure, which tended to focus on the gap, or the leap of faith or trust, or the responsibility each person had to the person prior to them. These gaps are reflected in the responsibility Cliff felt to enact the performance score of Kara [Walker] or Steffani [Jemison], for instance, and also the liberties he took in making the decisions about how to bring these scores, these words on a page, into physical space through his body and his interactions with the audience.

Thomas

It's really interesting to hear you talk about transcription, translation, and these literary references in terms of the scores and interpretations. Performance is so often theoretically pitted against writing as something ephemeral, embodied, and somehow outside of language.

Ryan

Right, whereas writing is cerebral, and something on a page that stands the test of time. Chris had paper in his hand and was reading the scores. He let the audience know what was being instructed, or what Cliff was being asked to do. And to add to that, Cliff would do this over a series of days or weekends, which added to the layering effect; as a consistent audience member, one is dealing with how the scores developed over time, from the beginning to the middle and over to the end, seeing if he began to take more liberties with the performances of the scores. I think he knew many of these people, so that also affects his interpretations.

Thomas

Let's sit there for a second. I'm curious, in terms of Steffani Jemison's score in particular, since she is an artist who you've worked with. It seemed to me her score had to do with knowing Cliff, or speaking on behalf of a group of women with whom she had previously spoken.

Ryan

There seemed to be a subtext; it was almost personal. You had the sense that Cliff was being slipped a piece of paper across a table. The audience wasn't necessarily privy to the content, but you had a sense that there was also something not there, that you couldn't possibly see unless you knew the dynamic between the author of the score and Cliff, I would say. And then I think because so many people in the room knew Cliff, there were other layers, other points of entry, other hierarchies of entry that people were engaging. But I don't really know Cliff very well. I met him after that performance later that day, so I'm not necessarily privy to that information or that history.

Thomas

What about the subtexts that are available? For example, the histories of gender and sexuality? In addition to the interpersonal subtexts and back stories, a number of Cliff's interpretations seemed

to be about racial and heterosexual paradigms in which he casts audience members to play out certain roles.

Ryan

I don't know if this actually appeared during the performance or not, but someone I know shared that they sensed a tension between the history of performance, associated with a kind of queer art history or trajectory, and the way Cliff is approaching performance. That is something that I was thinking about during, and after, the performances.

Thomas

Say more about that.

Ryan

I wondered what that meant. What is the history of performance within a queer art history or agenda? What is that theoretical foundation, and how is that different from what Cliff is doing, whether he says that it is different, or someone else says that it is different? I was trying to find out what they meant by that actually. It's also tricky because it's kind of essentializing these notions of performance, and kind of categorizing them. That's when I began thinking about the differences, or the possible resonances, between Cliff's mode of performance and a so-called queer trajectory. I would be interested, for example, to see if Cliff had invited Jacolby [Satterwhite] to perform, whether he would have brought out some music. Maybe Jacolby would have incited Cliff to step out of a role he plays so freaking well. In a way I get the sense that he is very conscious of his presence, or of his capacity to perform—not just when he's performing, but he's just very self-aware in that respect—so I think Jacolby could have really posed a challenge to Cliff, and asked him to step out of that, to step out of his "Cliff Owens," to step out of himself in a way.

Thomas

One thing that's interesting to me about working with an all-black cast of artists is that Cliff borrows the institutional mode of a culturally specific institution, building his own institutional platform in relationship to performance in particular. There's also institutional critique happening here, directed toward a variety of institutions and the ways in which performance has been institutionalized as a medium. What has been lost when institutions sacrifice more expansive taxonomies for a pre-determined concept of performance? Intermedia categories that attend to modes of spectatorship or experimental history, be they queer or in some way outside of the fold that's appropriate for museum settings, feel more capacious as a way of institutionalizing performance. In *Anthology*, however, we're presented with an alternative, with performance as diffuse and process-oriented. It turns MoMA PS1 back into a school.

Ryan

It totally turns PS1 back into a school! We're all sitting on the floor [during the performance of Shinique Smith's score], so you feel like you're in elementary school in a way, and you're staring up at some figure you're supposed to focus your attention on, and you're being asked to do things, and you really don't have a choice. Often, like you don't have a choice in school, or in school you don't know you have a choice at that age at times— I mean a few kids do, I wish I had been one of them, but by and large, you kind of follow along and you think you're doing not necessarily your job, but what you're supposed to be doing, and it turns out it is a job. You're being trained to follow.

Thomas

In what ways was failure mobilized by the project, and in what ways did it succeed in mobilizing that failure?

Ryan

Some of the performance scores were more opaque than others because of the relationship between the author of the score and Cliff. Some of the scores may not have been as rich as the author and Cliff may have thought they were, maybe because of the lack of background information. But I think that's fine if that's the reality, and I don't think it's a real failure at all. I think there are some performances that I missed, so I guess I can only speak to a very specific context. A challenge I often think about is: is the exhibition "the project," or just the series of performances? Maybe the "exhibition" actually started much earlier, and the residency and the exhibition are the same thing. Why aren't the videos documents, according to Cliff, but works in themselves? Not to say that there can't be more than one work generated from a particular set of actions—that's totally legitimate—but sometimes I wonder why the performances are conceived to be—I wouldn't say not enough—but often I think they're the most exciting or engaging part. So I wonder about the exhibition.

Thomas

The way you're describing it, there's also a gender component to it, like the exhibition is the reason to get it up, we can't just do performances.

Ryan

But what's the gender component?

Thomas

There's a certain level of masculinism there that favors product over process, and emphasizes the necessity to define an exhibition as a certain type of product that disqualifies or devalues the kinds of affective and relational labor that happen before and after an exhibition.

Ryan

In my mind, the exhibition really began with these performances, the residency period. You know, I would get emails from Chris almost every week telling me what scores where coming up, so I knew it was happening in my head. There were these works being produced, and I began to imagine what Dave McKenzie's score might look like, so in a way I did have that experience without actually experiencing Clifford enacting the scores.

Gary Carrion-Murayari in conversation with Adrienne Edwards

Adrienne

The performance you attended included three scores. What foremost stands out in your mind about the Kara Walker experience?

Gary

The most dramatic part was the moment when the lights were turned off and the anticipation of waiting for someone to accept Cliff's invitation for an encounter.

Adrienne

Yes, a kind of plea.

Gary

There's that very charged moment when nothing's happening, and you wonder what happens if no one comes up. Are we going to wait indefinitely or will he prompt the audience in some additional way? And also being in the dark with a group of people, some of whom you know and some of whom you don't, is a very charged experience. And being in a space that is dictated and controlled by an artist is something you're very, very conscious of. It was also interesting to know that it was Kara's work. Obviously the issues of violence, sexuality, control, and trust in Cliff's performance are ones that are very much inherent in Kara's own work, but these issues were transformed by the medium of performance. There was also a distinct spatial and auditory experience that is very separate from her [score]. It was interesting to see that once the lights came on, the tables were turned on Cliff a little bit; he did have a moment where he lost control of the situation, and that was very fascinating too.

Adrienne

What else about that score struck you in terms of the way the rest of it played out,

like the flashing of the lights?

Gary

A big part of it was the revelation of the identity of the individual who confronted Cliff. That score was very much connected to the experience of the whole afternoon, in which the personal relationship between Cliff and the audience, as well as his own personal biography, played such an important role. Certain pieces drew on that, but because he knew certain people in the audience, the relationship is different than it would be with a completely fresh audience or an audience who has no relationship to him. So to see who it was in the end, too, if it was somebody that he knew and whatever kind of tensions were in that personal relationship beforehand, that coming out in the performance was fascinating. Obviously it's a very deliberate thing to ask people that you know to be part of the event, as well as people that you don't know, but I think even he doesn't necessarily know how those prior relationships are going to play out in actual works. You saw that in other pieces too, where he's directly addressing individuals in the audience and they are giving very candid responses. Obviously the person who chose to participate had a very strong opinion of him, so that was very fascinating too. It made it feel more personal and it brought you into the intricacies of his world and his relationships in a more real way.

Adrienne

Yeah, because two women stepped up during the Kara Walker piece.

Gary

I only remember the one.

Adrienne

There was the woman who stood up who, later, after the score was done, we realized was going to be Cliff's student.

Gary

That's right, I totally forgot. I was thinking about the woman who had been his teacher.

Adrienne

She was the second lady. That was super interesting because I think that Cliff was completely taken aback since it took quite a while for someone else to come up. And then she comes up, they do the score, and then the lights come up, and during it Cliff is like, "Oh my god!" and we were all going, "What is going on?"

Gary

That was great. I had forgotten about the first one. I guess memory of performance is always a complicated thing.

Adrienne

What did you think really worked about that score?

Gary

Everything was really well planned. The language was perfect—all of Kara's language is always absolutely perfect. It was a great fit because it did take a certain degree of control away from Cliff, which I didn't necessarily remember from the other performances where he was completely in control and he was able to, I don't want to say manipulate the audience, but kind of pace the audience and have this mastery over the tempo and the language that he didn't have with Kara's score. That was really interesting—the contrast between the performances. And again, that element of risk always makes a performance very exciting.

Adrienne

So tell me what you thought of Shinique Smith's score, which was also performed in Cliff's studio space that day?

Gary

I think this one was really complex and engaging, and I think maybe I didn't feel it was successful, but part of that has to do with the personal nature of the score. I thought it was a really compelling approach by Shinique to attempt to trigger certain memories and experiences of Cliff's. And if it's unsuccessful it's just in that you can't control what comes out of the performer when you are trying to direct him or her. In that way, she had way more control over the performance again. Cliff could say what he wanted, but you could see his surprise at mentions of certain words, the trigger of certain names and things like that. It was more of a dance. It was interesting to hear what he wanted to reveal, or that at certain points he would just laugh or nod. Also having her there, it sometimes became a kind of knowing response to her directly. So there are certain things that as a viewer you can try to paint a picture of—what their experience together may have been like or what Cliff as a kid went through or remembers—but some of it is going to remain in him and some of it is going to remain between the two of them, what only they understand because they were there. So that made it very intriguing, but at a certain point, kept me out as a viewer. And I'm sure she probably expected some of that and didn't think that Cliff was going to sit down and speak one hundred percent candidly about every single thing he felt at a given moment in his life. Also, with the objects, it was a broader field of things that he had to work with, and some objects didn't really resonate at that moment, whereas if he had done it on a different day, maybe it would have been a different experience.

Adrienne

As I look down this list, the one thing that I certainly remember from that day based on the contents of the box was the beer. The beer was actually not a part of Shinique's score.

Gary

That was just something that Cliff brought in I think?

Adrienne

Yeah!

Gary

I definitely remember the beer.

Adrienne

He brings out this case of beer, and it's a beer that's from Baltimore. He passes it out to the audience, and has some for himself, and then has everyone throw the cans against the studio wall, some empty, some not. The interaction and how much he kept going back to Shinique was very interesting to me. That's why I love that you use the word dance because that's what it felt like. He was kind of like, "Wait, what was this? Where was this? Shinique don't you remember?" And she was like, "I'm not in the score!" But she was, so deeply actually in the score. Did you realize that Cliff had never opened the box before?

Gary

I did pick up that he hadn't opened the box before, which also lent a certain confusion to him because he had to improvise in some ways and it's easier to do that some times than others. There was a lot left to him to figure out and deal with, and maybe that's what didn't necessarily work.

Adrienne

So the last score that day was Steffani Jemison's *Regret Piece*, a very short score: "Experience regret. Do not apologize." What do you recall from this score?

Gary

I remember really loving that score just as a score. I think it's very poetic and very intense. It also feels a little bit like

a different era of scores—it's very '60s and '70s, but also casual and repeatable and universal in a really wonderful way. That, to me, felt like the most historical performance—reenacting a score that is an open-ended, very short piece of language, but doing it in front of an audience. I remember the slapping and things like that. That was very confrontational, to get people to talk about what they regret. That's when Cliff made it his own, because that definitely was part of the experience of the afternoon, meeting Cliff, but also having him engage with you directly and ask something of you directly, even demand something of you directly.

Adrienne

He went around and asked several people their experience of regret—if there was anything that they regretted.

Gary

That's an approach that he took. If you think about the score and if you had come across it in a book or in a museum, you could read those words and have it be a very private, personal thing, or you could do it with two people in a much more subtle way; you can do a million different things with that. But this was very much Cliff's take on it and it felt very personal to him, and it was also tied to the structure of the whole afternoon with that kind of confrontation. That's what really stuck out to me, loving the score and really loving it becoming Cliff's work through that.

Adrienne

I also was curious to know at what point Cliff decided that he was going to ask someone to come up and hit him. It was almost as though he was trying to elicit this feeling of regret or experience of regret from people in the audience because he was unsatisfied with what the audience had to say to him. No one

was really forthcoming. I think he asked if people had done drugs and one woman said she had done heroin. But at some point it shifts entirely and it's almost as though, okay, no one wants to really talk about this so let's enact something that should be regretful. So he chooses this woman that I later found out he had never met before, didn't know who she was. I was convinced that this woman was planted or knew Cliff or had some relationship in some way to him because why would you have someone get up and see if that person is really willing to hit you, to slap you as hard as they can? He said, "Take your arm all the way back and really hit me," and I think he did it three times or so.

Gary

He definitely played with the psychology of the crowd and the unpredictability of the crowd. That capacity for violence was part of a bunch of the performances, when you saw the bricks and the baseball bat in the performance of Shinique's score and in Kara's performance obviously. I think it made sense that at some point violence had to be part of it.

Adrienne

He'd been tiptoeing around it. It had been very subtle.

Gary

Yeah, and it's personal to Cliff in that afternoon, but I think it's something that in performance is always there. If you think about Yoko Ono's *Cut Piece*, the crowd always has the capacity to act in extreme ways if you prompt them. I didn't know if Cliff knew the person or not, but it wasn't that surprising because of that charged quality of the whole space and the format of what he was doing.

**Eugenie Tsai in conversation with
Adrienne Edwards**

Adrienne

I thought we could start by talking a little bit about how you came to know Cliff's work, and then we'll talk more specifically about the performances you saw and get your overall reactions towards the project.

Eugenie

I think I learned about Cliff's work in the 2005 *Greater New York* exhibition. It really stood out. In terms of his performances, sometimes I find myself thinking, "Why do I go to these things?" because I know I'm not going to be able to just sit, as I sometimes do, in the back and leave if I decide I need to go. You're always somehow involved or implicated in whatever it is he's doing. When Chris [Lew] told me he was doing a show of Cliff's work I thought "Wow." He's been a big fan of Cliff's; I really admire Chris, we worked together at P.S.1. I have to admit that I had a moment of exhibition envy. I liked the performances Cliff did with Joan Jonas and other performance artists in which he let them manipulate him as a subject or a tool. I admire his ability to put himself on the line. In one way I think he's such an exhibitionist, but then on the other hand I think he's amazing in his ability to just let go of his ego and become a passive tool.

So, Chris said, "You should come to one of these performances if you can," and I thought I really had to go because I had no idea what he'd been up to. I'd heard that he'd been living up in the archive room and figured it would be fun—well not fun, but interesting, always interesting. I liked the idea of asking other artists for scores and then performing them. He does collaborate with other artists in a really interesting way. I loved the Maren Hassinger performance.

Of course it's always nervous-making to see a naked body in the room, but Cliff somehow diffuses it in a remarkable way.

Adrienne

I think he's so precise in his ability to gauge the room.

Eugenie

It's a little frightening.

Adrienne

It's incredible. And he has this stance that he takes, and I've come to tease him about this stance, which is kind of wide-legged, with his hands in his pockets, and he's in all black, standing there, and he just reads the energy, and then he starts to speak. I've come to call it both seduction and manipulation, but also entirely through the sensibility of discomfort. That's the "I know that I'm not going to get off the hook," as you were saying.

Eugenie

It's definitely the aesthetics of discomfort, but the question then is why do I keep coming back? I come back because I wonder what he's going to do. It's just the seduction, the fascination with him and his person. Oddly enough, it's about him, but it's not about him. I was thinking about the Maren piece...I loved it because there you are lifting Cliff, and it's almost as if he's a box or a package. It's heavy and you need several people, but at the same time it's a living being, a body. I was doing it with several people and I realized we were just kind of dragging him across the floor, and I thought, "Oh his butt! I'm sure it's getting scraped because we're not really strong enough to lift him up." He was such a dead weight, and I knew he was intentionally being an even deader weight than usual. It was interesting that he was an object you were trying to manipulate as a thing, but then you realized he was also

a person so let's not let his back slump, let's try to be nice to this body. But he was very good at being blank in that case, whereas in the Kara Walker, he was so completely charged.

Adrienne
What day did you see the Kara Walker score?

Eugenie
Friday, August 12th [2011].

Adrienne
I am very interested to know, because he did them in such different ways every time. We tell him that he's become obsessed with the score because of how entirely complicated it is on many levels, and actually creating work out of it, but also there are all kinds of moral implications in this work.

Eugenie
Maren's was much more straightforward in its actions, but I really loved it because it was so deceptively simple.

Adrienne
It was an elegant, poignant piece.

Eugenie
And it also reminded me oddly of the beach. You could create a narrative around it, but it was very '60s with its use of the body and actions. Whereas Kara's, when he was reading it I thought, "Oh this is just so perfect!" I don't know her well, but it seems so her—to make everyone uncomfortable, particularly with some sort of sexual exchange. But then it becomes very charged because you have a black man and then everyone else in the room. I had, on that day, run into a curator from Hong Kong, Tina Pang, who showed up. So I was standing there next to Tina sending out my mental message to Cliff, "Okay no, no, no. You know me too well, it would be too weird,

you just wouldn't do this." And I was standing next to Tina, and of course he kissed her. I was thinking, "I wonder how she's feeling about this." But she seemed to be fine with it, whereas I realized there were probably other people who were rather offended. I think I saw some of those reactions in the pictures or someone told me, maybe Chris or Candice [Madey]. It just depends on the individual I guess. But that was definitely the most uncomfortable moment, as you're leaning against the wall thinking, "No, no, no, no, not me." But once safely not chosen, as a voyeur, the whole thing becomes extremely fascinating. You wonder what people are thinking: they look angry, they look uncomfortable, or they're kind of liking it. And then there's the question of how Cliff can do this. How does he figure it out and how does he feel? The whole complex dynamic was mesmerizing.

Adrienne
It's as though the artists really got into Cliff's head. The scores represent their work, very much the kind of work that they make. Kara's score is actually a perfect example of this, and so is Jennie Jones's—I don't know if you saw that one. But they are both so understanding of Cliff's techniques, particularly of the body and also of the psyche in his performance works.

Eugenie
Well when he channeled other artists earlier, Carolee Schneemann, Joan Jonas—

Adrienne
Ben Patterson.

Eugenie
Yes, Ben Patterson. I don't think I saw footage of that. But it also seems to be a kind of, "Where do I fit into this lineage and what is my place in this larger history?" and also, "How can I learn by

channeling these things as well?" But it is an interesting collaboration because it is so rarely just about him, even though obviously you have to have a really strong sense of self and an ego to do work like that. You have to be an exhibitionist, I think, on a certain level. He's such a complex, complicated person. I find myself looking at him during these things thinking, "Who is this man? Who is this person?"

Adrienne
Are there other performances you saw that you remember? We've talked about the Kara Walker, and you're in one of the photographs.

Eugenie
Right, looking at Tina. I talked to Tina after, and I said, "So..." and she looked really happy and she said, "Oh, I had onions for lunch." What a funny thing to say. But she just smiled and looked very happy, and I thought, "Oh that's good, you're not feeling totally abused or anything."

Adrienne
What do you think about the overall project? Any comments related to this monumental task that Cliff has taken up?

Eugenie
I just thought it was a really impressive undertaking and a really important one. I know Valerie Cassel Oliver is working on a show [at the Contemporary Arts Museum Houston]. Over the past two years performance has really come to the fore, and it's just amazing. I think it's a pretty fascinating development. I'm wondering where it is going to go, and that also involves recouping history, reconstructing the past, and also starting to chart the present. I wonder, why now? What is it about now? Does it have to do with the market and the inability to sell anything, so artists return to doing more

interesting, experimental work because if there's no market you can pursue what you're genuinely interested in? I really don't know what to think. Everyone is doing performance, everyone is doing something interactive, but why? What is going on?

Roundtable

Derrick Adams, Terry Adkins, Sherman Fleming, Maren Hassinger, Steffani Jemison, Lorraine O'Grady, and Clifford Owens in conversation with Kellie Jones.

Clifford

I'd like to thank everyone for being part of this conversation. I'm so impressed and deeply moved by the presence of all of you and by your participation in the project.

Anthology is a kind of "gift economy." Writing the scores was a generous act, and I think that same spirit of generosity is what fueled the performance art that was happening in Los Angeles, when you, Maren, were working with David Hammons, Senga Nengudi, and others. Anyway, thank you. I'm also honored that Kellie Jones was generous enough to moderate this discussion.

Kellie

Thank you, Cliff. It's great to be a part of this project. I want to start by asking: What cultural work does performance do in your practice as an artist? What can you do through performance that other mediums don't allow?

Maren

What I've come to is that I'm doing my life. I'm having my experiences, and I'm doing my life. Sometimes it comes out in performance/video, and sometimes it comes out in installations, and sometimes it comes out in objects. But always, there's a sense of motion, there's a sense of a relationship to nature, and lately there's been this real interest in audience participation. It's the idea that there would no longer be a passive audience. Instead, the barriers between audience and artist/performer would dissolve and the whole *thing* would become participatory. Culturally, this becomes an ideal for life.

The thing about performance is: it's real, it's you. It's your body in front of people, or next to people, or wherever, in ways that you can't be in a photograph, installation, or object. You're there doing something, in front of, next to, behind other people in real space. I feel it is the most direct way of speaking to people. Once when we were out in LA and we were getting ready to do *Kiss*—inspired by Senga Nengudi's piece from the 1980s—my relatives came to the opening [of the 2011 exhibition *Now Dig This! Art and Black Los Angeles, 1960-1980*] and my cousin kept asking, "Well, it says you're going to do a performance. What kind of performance are you going to do? What is it? What is it going to be?" All I could say was, "Well it's gonna be very visual." The cousin who asked those questions didn't make the performance. Those that did attend were complimentary. But I'm not sure, when they got there and saw it, whether they knew anything about what they were looking at or not. Frankly, I was unsure myself. In any event, people sang along and accepted our gifts and may have felt a lift in spirit—which was our goal.

But here's the thing: because you're using your physicality as the medium, your peculiar presence becomes very important. Hopefully the audience can identify with

that presence. Generally I focus on the real. Issues like daily activities, self image, and our likeness as people, etc. So, performance can speak about unity and bringing everyone together.

Steffani

In terms of my own work and performance, I tend to advertise for performers. They tend to be amateur actors, people who aspire to careers as actors. Often they're young people of color, college age, usually men. And they have certainly absorbed ideas through popular media about what it means to perform, and who their audience might be, and how they might be perceived on camera or by an audience. Often I'm interested in engaging their ideas, and I do work a lot with improvisation. The fact that the performance doesn't happen in a specifically visual art context makes it possible to pursue the kinds of ideas that are interesting to me. In terms of how visual artists work differently with performance, my background is also in film. I was trained in narrative filmmaking and a lot of my working technique is informed by those kinds of approaches.

Lorraine

I've found that the least interesting part of performance for me right now is the use of my own body, my own presence. In fact, I actually stopped performing—not just to slow down the ideas, but to eliminate my body—because I found that since I had started performing so late in life—I mean, I entered art as a forty-five year old—I was using up the last of my youth in those early performances. Were I to have kept performing, using my own body, I would have inevitably raised issues of aging. And aging was not an interest of mine. It was not the subject matter that I was exploring. So it was an inadvertent conflict between the body that I was and the message I wanted to say in performance. But the performances that didn't necessarily involve my own body felt like a very satisfying way to create situations for others to enter into or to express themselves in, or to put other people in motion. So in effect, it's sort of like directing film, something in which you set up the situation, and others execute or elaborate the situation. That's the only way that I feel I could do performance now. I could not be the central performer ever again.

Sherman

It's interesting you're saying that. I like the body. I think that's what's always drawn me to performance. I went to a concert; I think it was when James Brown got out of jail the second time. It was at Constitution Hall [in Philadelphia], and by this time, I guess it was the early '90s, there was a lot of fanfare. He had dancers and the band was playing for like forty minutes. Everyone was asking, "Where the heck is James Brown?" Then finally James Brown comes out, and his first song is "Try Me." And he's singing and the energy was really low. He was clearly showing his age, and at a certain point he was using the old corded microphone on the stand even though this was a time when you could have a wireless microphone. I was thinking, "Man, what is this with these creaky old instruments anyway?" He comes to this crescendo, and he kicks the mic stand forward, and then he spins and he jerks it back, and he lands

on his knees, and the microphone perfectly lands in his hand. It changed the entire audience. It was this amazing, magical thing. It's that aspect of a guy who's done that all of his life, and even though he was, by this time, in his sixties, he could still recall that power and majesty with just a couple of moves. And that's what resonates with the type of work that I do, and the type of work I've always wanted to do. That the body still goes no matter what, whether in your twenties or your sixties or your seventies, like James Brown and blues and jazz musicians: they still go. They're still doing it. They're still recalling that magic.

Terry

I consider myself not to be a performance artist per se, but rather a recitalist, meaning one who attempts to create a synesthetic, installation-based experience built on various themes, where the spectacle of black music traditions are brought to bear. I'm influenced by the promotional photos and stage settings of early territory bands rethought as installations proper and the continuum of this tradition in the avant-garde as manifested by performing artists like Sun Ra and the Art Ensemble of Chicago. The Lone Wolf Recital Corps is a performance unit with revolving membership that is a laboratory for working out these ideas as they relate to installation settings and subjects.

The first performance that I saw in the true sense was by Sherman Fleming in 1980. We both were in a group show at DC Space curated by Keith Morrison called *Alternatives by Black Artists*. I came to the opening and saw this brother with bolted boots, hung upside-down from the ceiling with mirrors stuck to his body revolving like a disco ball to James Brown music, I said "WHOA! What is this?!" (*Laughs*).

Clifford

Strong image.

Terry

We started collaborating after that (*laughs*).

I'd just like to throw something out here. This is a beautiful gesture by Clifford to address our invisibility. He's taken this solo situation and made it a platform for making a statement about that. I want to quote the pianist VJ Ayer, who I think begins to address the nature of our absence from the contemporary canon. He says: "What I've found as an artist of color in America, is that we are most often called upon to represent yesterday's traditions; to be repositories of the ancient; to perform ethnicity in a way that poses no threat or challenge to modernity. It is shockingly rare that artists of color are invited to become full participants in the national conversation, to respond to today's world, and to offer a glimpse of tomorrow."

Derrick

I always consider making work to be like having a conversation with another artist of the past. One of the things I realized is this is the first time in history that a black artist of my generation can communicate with another black artist of a past generation. Artists of the previous generation may not have had an artist to refer to. They

might have been referring to Duchamp. I don't have to refer to Duchamp when I'm making work. I can think about David Hammons if I want to think about those ideas. I don't have to go that far back. Like a musician who is making hip hop, he can refer to R&B. He doesn't have to go back to jazz. Even though jazz is still attached to R&B, he doesn't have to go back that far.

Lorraine

Derrick, do you think that there is a lesser degree of self-censorship within, among black art-makers now than there was before? Do you think that's changed?

Derrick

Yes, less. If we have a lack of self-censorship, it'll help artists who are good or who are bad to distinguish themselves from other artists. The best way to know what you are is to know what you aren't. When you look at another artist's work that is not the thing that you would do, it helps to define your direction as an artist. I think this is the first time in history where there's so much out here, good and bad, that you're able to make that distinction easier.

Terry

I don't agree with your first statement at all. It's not the first time in history that transgenerational communication has ever been possible. There have always been black artists who came before any of us whose legacies have been available to converse with in any number of ways. Truly exercising the kind of freedom that you're talking about means also being free to refer to Duchamp if you want to, and to not arrest it at David Hammons, or any other artist. You have the freedom to do anything you want!

Lorraine

I brought up this issue of communal self-censorship for a reason, and that is because when I began my performance, it was with an act of criticism of the community. This was received as a reprehensible act because the community was not supposed—to use the old phrase, "not to wash your dirty linen in public"—to make criticisms public outside of the community. The first problem that I had was that we as a community learn about ourselves the same way everybody else learns about us, through white media. There really weren't many options for making effective critique within the community. I always believed that a community that cannot critique itself, even publicly, is a weak community. I certainly loved the black abstract artists, but I felt that this was 1980, this was a different moment than the one that they had been working in, and required new approaches.

Clifford

I don't think that black artists in the US enjoy that kind of freedom, especially in performance art. I think even when Sherman was hanging by his feet with mirrors attached to his body, that was radical. That was not the way black male bodies were supposed to be presented publicly in a work of art. Something I often come up

against in my own performances is: Why do so few black people attend my performances? Why are so many black people uncomfortable with my nudity or the ways in which I deal with my body? I often say, and this might be problematic, that there's no such thing as black art. I'm more interested in American art. Black art really is, in fact, a black middle-class position. Black art is driven by a black middle-class ideology and that ideology is such that the presentation of the body that might make a spectacle of the black body for white consumption is not appropriate. Some black audiences, and white audiences, are quite comfortable with a kind of, well, coonery buffoonery.

Terry
So you're talking about the performing of ethnicity as VJ Ayer stated.

Clifford
Exactly.

Terry
I think *Anthology* in every aspect displays that there is a performance to ethnicity in ways that are unfamiliar; one that is not stuck under the ceiling of possibility framed by a dominant culture for what has been branded "black entertainment" in America.

Sherman
There's an issue of commodification. Like the minstrel; minstrelsy is a commodified genre. And there are many people who do it, and there are some who do it incredibly well. For me, as much as I can determine that that's great and that's fine, I couldn't do that. I want to be able to look at something or see something or experience something that lacks a name. Like the first time I saw the Art Ensemble! Or the first music I heard by them. It's like, what is this? And spending years and years trying to figure out what that is, and by the time I figured it out, to paraphrase Ishmael Reed's *Mumbo Jumbo*, the moment you figure out what black people are doing, they've gone on to do something else (*laughs*). Because that is what runs our culture! Whether it's R&B, whether it's dance, whether it's performance, whether it's poetry, whether it's spoken word, there's this noncommodifiable energy that runs through our society. It really can't be defined, and by the time it is defined, something else is happening that we haven't witnessed.

•

Lorraine
Cliff, what made you think of *Anthology* as a score-based project? Had you been doing scores before?

Clifford
When I was artist-in-residence at the Studio Museum in Harlem in 2006 I

performed four scores by Ben Patterson, which I think was the first time the museum presented Patterson's work. So in a sense *Anthology* is greatly indebted to Ben Patterson.

Kellie

Maybe this is a way to expand upon these ideas: what are your thoughts on Cliff's performance of your score?

Clifford

Uh oh...(*laughs*).

Sherman

Well, he didn't do it the way I would have done it (*laughs*). But you did it and I thought, "Oh, that's great!" Your interpretation—I mean, there's a very serious work ethic. It's a lot of hard work doing that painting and all that, and I liked the way you documented it. When I first saw the show I had issues with how you installed the documentation, but I had to let that grow on me. I came back and looked at it and thought, "Oh yeah, okay that works." But I had to keep coming back to it to form a relationship to something that I thought was uniquely mine, but really was not. That was the process I had to go through. So for that, you get an A.

Clifford

Thank you.

Terry

I feel similar to Sherman. For me, there's a disconnect between the audio and the image. But the image so powerfully captures what I was thinking. It's evident in the photograph; it's just captured so well. There's a sweetness in the photograph that is Bud Powell. There is an angelic distance that is Bud Powell in that photograph, so much so that I almost don't even hear the audio part of it. But since I know that's what it brought you to, I dig the audio too.

Derrick

I was more interested in the idea of having you interpret the work in a way that I didn't think about and for me to learn a new way of seeing something, or communicating something. I was hoping that you would do something totally different than I would do.

Terry

I think there's a mutual exchange of surrender on the part of both artists. Our surrender and trust in Cliff to do it; and his surrender and distance, to surrender himself to what we wrote out for him. That's also a thing that's very beautiful about it.

Maren

Great collaboration. So you can distinctly hear the two voices.

Terry

I'm a little pissed off you didn't put that plant in, the fern—

Clifford

I know (*laughs*).

Sherman

I like the complexity of it. I read the score and tried to affix the score to the documentation. I'm doing that throughout the exhibit.

Clifford

It doesn't always match up.

Sherman

Which is great!

Maren

There are some people missing, right?

Clifford

Yes.

Terry

In the number of times that you have had public performances of the scores, how much variety has there been? What determined the frequency of performances?

Clifford

When we put the scores together—I call them performance medleys—it's important that they have some kind of connection to each other. There's a curatorial process that we go through when we decide what scores to do live. I've done some of the scores many times with different interpretations. Kara Walker's score I have probably done ten times now. Steffani's score maybe five times. Lorraine's four times. Terry's score I did three times in a single day. The audio-based performance scores, like Jennie C. Jones's score and Terry's, I needed to do them again and again. It's important that I do them multiple times, with multiple iterations and variations on the score. Sherman's score, I want do that one again in a different context.

It took me a very long time to figure out Kara Walker's score. A very *long* time. And I'm still trying to figure it out. Even Maren's score took a long time to figure out. I've certainly absorbed everybody's score. It's in my body, and it's in my psyche. And my interpretation of Steffani's simple score, "Experience regret, do not apologize" is to have people experience regret with me and not apologize; I'm absorbing their decisions to humiliate me publicly in those performances. And some of you were there—you were there at that performance. It was quite intense.

Maren

It was quite crowded.

Clifford

Yeah! Or making my body, in your score, Maren, accessible to the audience.

Maren

These strangers' hands...

Clifford

Yes, strangers' hands all over me. Can I ask one question, before we move on? And we don't need to get into it too much, but with everybody's contribution to the project, and considering where performance art is now versus where it was thirty years ago, and thinking about the marketability of performance art, have any of you thought about or found it problematic that *Anthology* has a kind of market value placed on it? And what does that mean, say for Maren or Lorraine, who were making works since the '80s, without any consideration for where the work would end up, historically or in the marketplace?

Terry

It means you should give them a 50/50 split! (*Laughs*).

.

Clifford

I'm asking the question because we started out talking about performance art, something that has historically existed outside the mainstream. And now that it has become kind of mainstream and because artists of color *rarely* enjoy commercial success—not that I'm enjoying tremendous commercial success—but that perfor-mance art is now enjoying some kind of market success, and that this project has a kind of historical dimension and meaning.

Sherman

When I got the full scope of what you were doing? It made me think about again those blues musicians whose work was ripped off, and they spent half their lifetime trying to grab some of the royalties, just saying "That is my piece," or "That's my song." The fact is that you're paying homage to the practice and to the practitioners.

Lorraine

I'm a little more cynical. I feel that, at one level, you could say that the show is mutu-ally exploitative. Possibly you used us, and we used you, and why not? I think it benefited everybody, and the great thing about it was when I walked in and I felt, "My God, this show is so much bigger than Cliff, and each of us individually, and it's bigger in spite of us." Do you know what I mean? We gave our individual little scores to you, and you did your little performance, and you're taking your clothes off, and you're doing your little Cliff stuff! But the Cliff stuff that you did, and the stuff that we all did, somehow added up to something so much more than any of us.

Terry
I think it's important, too, to keep in mind that not only is he paying homage, he's also taking the risk of dealing with very young people. And that's also a great risk, very generous, and very strong.

Steffani
I might be the only person who had the privilege of studying with Cliff. He was a visiting professor at the School of the Art Institute of Chicago when I was in graduate school, and one of the things that he talked about, and that I think about a lot, was the importance of resolving the work for presentation. We thought about what it means to produce or develop or generate material for a work, and how it's presented to the public. It was something that was clearly preoccupying him as an artist, what it means to transform this practice that existed between performance and photography. The tension between performance and photography, and also the kind of question about the relationship between the production of the work and its documentation, is really present to me, even in the exhibition. What does it mean, as someone who attended many performances, that those performances can be considered "the work"? I felt as if I was in the presence of work happening, work being made. I was so surprised to see how the photographs turned out to be something completely different. That's just something that I've been thinking about in relation to this question, and in relation to how the show connects to the performances. I definitely didn't design my score for documentation. It was created as this very private, personal thing. It's not visual at all, actually.

Lorraine
You didn't think yours was visual?

Steffani
When I developed the score "Experience regret, do not apologize" I imagined Cliff taking a private moment, maybe in a room to himself, maybe in a bathroom, maybe while cooking, experiencing regret, and not even having an opportunity to apologize.

Kellie
Can we talk further about this idea of the dissonance between the actual physical performance and its documentation, whether in photographs or as a written score?

Terry
I think that the driving force behind all the pieces in the show is that dissonance and the varying degrees of it. I'm sure everybody here has different ideas about what it is that was written and how it ended up being. With every piece I feel there are varying degrees of dissonance that bring it to life!

Lorraine
For me, the score is research. I set up a situation because I want information; I want

information on how people conceive the other. And so any interpretation of it is a valid interpretation; as far as I'm concerned, it's all information about how the other is conceived.

Steffani

To clarify, the dissonance that I was talking about, it's not between the score that was written and the realization, but rather the performance as it's experienced, and the documentation as it's experienced and represented. I don't even know if it's accurate to use the word "documentation" as if it's secondary, as if those photos are secondary, because I don't think they are. They're two different things. And that's the kind of tension or relationship, that is really interesting to me.

•

Kellie

Do you all think this project makes visible an African American performance history?

Lorraine

I think that the show reveals the presence of a history without being a history itself. It was not a historical show; it did not give the history of black performance art. It simply, in some ways, just revealed its existence. We hate to say that, but they didn't really know we were here, so it revealed the existence of a black perfor- mance history. We're still at this stage now, really, that all we're doing is presenting ourselves to art history for examination. We're at the debutante ball, presenting ourselves, right? Not for our potential suitors, but—yeah, okay, potential suitors! We're all here for the PhD candidates who want to come.

Derrick

As a contributor of a score, I wasn't necessarily aware of the fact that it was only African American or only black artists participating. To me it didn't make a differ- ence. I was more interested in the conversation that was involved, and the work, and the show itself. If I had seen black-and-white Xeroxes from Kinko's on the wall, I would've been okay with that. I thought it was interesting because it was like a letter. It doesn't have to be grand or anything. That's one of the things I like a lot about looking at artists like Ben Patterson, and looking at some of the scores from the past: seeing the rawness of things and how that rawness is actually acceptable in our culture as mainstream objects.

Terry

In taking Kellie's question a little bit further, when you found out that it was an all- black show, did any of you feel uncomfortable with the prospect of a certain kind of racial cluster, ghettoization, another black show?

Maren

I knew from the beginning that's what he was doing, and I thought it was incredibly ambitious. All those voices...

Sherman

I understood from the beginning that it was going to be about black performance art; black visual artists who do performance. And I thought, "This is fantastic." So I didn't really see it as a sort of cubby hole, a categorical thing. I thought, "This was a long time coming. Maybe this is the beginning of something."

Lorraine

I was curious: were there any people that you asked who said no?

Clifford

Oh, many. And then there were some who agreed to contribute a score, and then they got busy and they couldn't do it, so there were quite a few. I reached out to a lot of people, but for whatever reason, some weren't interested—maybe for the very reasons that Terry just explained. I think that may have had something to do with it. I hate to use this word, because it's overused, and grossly misunderstood, but post-black. But I think US visual artists working in performance have always and only been post-black. In a way, to be a part of this show, it means you're functioning as an artist outside of a mainstream. It works against the grain of all those assumptions people might have. But then I think there may have been a lot of fear for some artists, to be a part of the exhibition. Which is fine too.

Lorraine

Why?

Clifford

I think that performance art is challenging. And I think the scores that you all contributed to the project are challenging. I think in some cases even more challenging to you as artists. It is also challenging to me as the interpreter, the conduit, and subsequently challenging to the public that consumes it.

Lorraine

You know it's interesting, just to unpack the phrase "post-black," slightly? I mean as you know, I always go around saying, I mean every time I give a lecture, I say, "Well I was post-black before I was black" (*Laughs*). I think there are people my age who know what I'm talking about! Any black person who grew up in the '50s in a certain social class and with a certain level of education—especially if they had achieved what was possible in the limited meritocracy that did exist in some parts of the country, particularly the Northeast—would understand. Many people of that class assumed that they had escaped from the limitations of blackness.

Kellie

As I see it, African American art history was post-black before it was black. In the

nineteenth century, black artists were not necessarily depicting the black body. They had only recently been able to work as fine artists. In the US they were still working out how to represent a black person. You think of people like Robert Scott Duncanson, who was largely a landscape painter. The one painting he does with a black figure [*Uncle Tom and Little Eva*, 1853—after Harriet Beecher Stowe's novel *Uncle Tom's Cabin*, 1852] gets horrible reviews. And that was it for Duncanson in terms of outlining a black image; he never took that further. How does a black person represent what he himself looks like, or what she herself looks like, in the face of overwhelming stereotypes or images of servility, and was there a market for anything outside that type of framing? So there was a caesura that they were working out how to fill in over the nineteenth century. African American artists of the nineteenth century didn't show black people for the most part. If you look at the majority of their work, they're showing landscapes, or they're showing allegorical figures who are supposed to be black—but don't "look black" in a phenotypical sense, as in the sculpture of Edmonia Lewis.

With the growth of a critical mass of artists and art, African Americans are able to deal with the idea of the black figure in the twentieth century. And then this ends up being something that becomes identified as "black art." But that heavily freighted term is also very much part of the language of the 1960s and 1970s. "Post-black" pushes against such reductive thinking. However, it is a phrase that has its own limitations because I feel it doesn't take into account the long history African American artists have in which the black figure was not a part of their production. So this is perhaps a roundabout way of saying that it makes perfect sense that Lorraine had a more expansive view of what blackness could mean creatively, in advance of these types of late-twentieth-century categories.

Terry

But it's interesting that Duncanson, Tanner, and Bannister were also community photographers.[1] They were self-employed entrepreneurs. So, while they might not have been depicting blackness in painting, they most certainly were documenting it while providing a service to their community. It's dicey to project from hindsight, but I wonder whether this activity also emerged out of their need to find alternatives to freely and creatively depict their people without the constraints of art-world prescriptions that Kellie has pointed out.

Steffani

Cliff, you mentioned at the beginning that you feel that many—you feel that your audiences aren't necessarily mostly black, or that a lot of black people don't come to see the work. And one of the things I really like about what white audiences see when they see your performances is that you refuse to suggest you're a neutral vehicle for performance. Your performances never ignore the ways that you're perceived socially and culturally. You also resist allowing anyone else to perceive themselves that way. When speaking about white female performance artists people never say, "This work is therefore about whiteness." No, of course not. They never say that. But of course it is! Their work is often about whiteness. It just isn't acknowledged.

1
Henry Ossawa Tanner (1859–1937), Edward Mitchell Bannister (1828–1901).

Derrick

The score I gave you was really based on something as simple as a TV commercial, which was Puff Daddy in a commercial for Proactiv, and he was talking about the product. He was speaking to the audience in a basic way that I like to hear. It was something that appeals to me in every way as a human, and the line he said to the audience was, "I just wanna be straight up with you: I just ain't want no bumps."

•

Kellie

In critical and academic discussions of performance art there's a tension between the live act and the document, the latter being emblematic of a fixed history. In putting together *Anthology*, and having this roundtable, do you think there's danger in codifying the history of African American performance art, similar to the way "black art" seems to signal a narrow view of African American artistic practice? Is this project antithetical to preserving the freedom of the live act, as well as antithetical to preserving an uncodified blackness? Or is the need for histories of African American artists more pressing?

Sherman

I think that historically, when I think back to the '80s and the '90s and the culture wars—what did the culture wars result in? The culture wars were a win for institutions that no longer had to deal with individual artists. If performance art is an outsider practice, that meant all of a sudden that access to a venue was now stripped. You really had to have an institution to back you up to have something. And for those who do not have that, well then you're ass out. So I think it is important to be able to categorize or codify this particular type of practice. Not to mention the fact that, as far as in a Western tradition, performance is over one hundred years old. It's an old art form. It's even a tradition, but no one knows what it is. And that needs to be defined, and that needs to be shaped.

Clifford

I'm happy to run the risk of codifying history. I think it's necessary. I always wanted *Anthology* to be problematic and I think it is on a lot of levels. How is it possible that I've placed myself at the center of a broader conversation? I've placed myself at the center of this history. It's me all the time! Me me me me me. We know of course, as Lorraine mentioned, it's much bigger than me, or all of you. But it's my representation that in a sense drives the work, drives the project. So that, I think, is a problem! But I don't think it discredits or somehow devalues the individual artists who contributed to the exhibition.

Kellie

What are your thoughts in general about the concept of the score in performance? Had you ever produced one before this project?

Lorraine

I want to thank Cliff because actually I was moved to write a "score" for the first time, as opposed to a more directive "script," the sort of thing I would do for my own work. But eliminating any and all directions that might limit interpretation was the answer to another set of questions that I had had about my own work. So in the end what I gave Cliff was not something just for Cliff. As soon as this show is down, I will put it on my website and offer it to the world! But it was Cliff's invitation that enabled me to think about the "score" very self-consciously. So it was a first time for me, and I'm definitely very appreciative.

Maren

I've written scores, but I never called them scores. They were my scripts for action or interaction between people who were in the performances. So this is the first time it was "scored" and adapted. In the past, I'd given directions to people, but it was in a piece in which everybody was given directions to do things. It wasn't like I gave a cast directions for broad interpretation. I held the reins. So this was the first time I just let the thing go. And it worked out great! What I was really shocked about was that some of the stuff that's always going around in my head, I could see Clifford had done intuitively. In each person's case, I saw him honoring that person. Even though his adaptations might not have seemed so, it was always very honorable, very sensitive.

Derrick

The thing I enjoyed about being asked to contribute a score is that it confirmed just the way that I think about making art. I'm excited to show in places and do projects, but I think art is just a basic practice in which I would feel just as happy if I had a piece and wanted to do it in the street. Or if I wanted to do it in an abandoned building. The communication of the art could be anywhere. And this is one thing that I talk about a lot with artists, younger artists. You don't have to be in a fancy space or an institution to communicate an idea or do an exhibition.

I'm hoping this exhibition will influence a lot of younger artists about their ideas of the art world or the mainstream art world, and how to communicate their ideas from a very basic place. I don't believe there's an outside or an inside anymore.

Lorraine

Derrick, I can't let you get away with this altogether (*laughs*). You're dealing with a problem that we wish we could have dealt with. The thing that you're describing is where we started. And then we got institutionalized! And now, it's interesting that you are feeling like you have to struggle to get back to where we were before we got institutionalized. It's great! I love it!

Terry

What I found interesting about the whole score idea—and in viewing the show—is the coexistence of a document in darkness that, if you will, is brought to light by Clifford's interpretations. I sense a certain amount of withholding in the documents in *Anthology* and you, Cliff, act as the conduit for bringing them to light. To enable

the brilliance that exists in the luminosity of an idea as it appears on paper is the most interesting aspect about the score. It was something I'd been already thinking about. With my exposure to ideas about endurance that I've experienced through Sherman's work, I kind of had written it for him.

Sherman

Let me play my old man. Back in *my* day (*laughs*) we didn't have this. It was really about, "I'm gonna have to forge my own way. I'm going to have to build my own structure. I'm going to make my own environment, make the tickets, make the poster, get all of this together, then I have to do it all over again the next time." I understand and appreciate performance being this outsider practice. Clifford, I have to say, when I got the call from you, it had been a fantasy that if I keep doing this, somebody's going to call. There's going to be some black grad student that's going to say, "I saw your name on some little ticket there, and I just decided to hunt you down and go, 'Who are you?'" (*laughs*). I've held on to that for thirty years, and then you called. Going through this exhibit is fantastic. To see all of these people who were doing what I was doing, but we were just cut off from each other. We didn't know. I didn't know until now that it's here and it's great and it's fantastic. And now there are so many more opportunities and venues. Back there when I was your age, not having that was really, I don't know, it was kind of painful. It was kind of painful to get up and do the whole thing, get some appreciation, and then having to do it all over again, and convince people all over again that this is what I'm doing, and them believing in me enough to give me the spot to do it. And doing it again and again for thirty years. It can wear on you! I guess I'm happy that there are so many more people who think of themselves as being in this rich opportunity of creativity. But it really wasn't like that all the time, and it took a lot of work. It took a lot of hard work to do—and just sort of stick to it, believing in what you're doing is really important enough. So I thank you.

About the Contributors

Derrick Adams is a multidisciplinary, New York-based artist whose practice is rooted in Deconstructivist philosophies and the formation and perception of ideals attached to objects, colors, textures, symbols, and ideologies. His work focuses on the fragmentation and manipulation of structure and surface while exploring the shape-shifting force of popular culture in our lives. His creative process is invested in ideas that shape formal constructs, resulting in two- and three-dimensional works, as well as performance. Adams allows the medium to work in its own favor and to construct a formal language of communication.

Terry Adkins is an interdisciplinary artist, musician, and cultural practitioner engaged in an ongoing quest to reinsert the legacies of unheralded immortal figures to their rightful place within the panorama of history. Under the auspices of the Lone Wolf Recital Corps, he stages emblematic installation-based experiences that utilize a variety of real-time and static media. Adkins has exhibited and performed widely since 1982 at venues including the 2012 Paris Triennale; the New Museum, New York; the American Academy in Rome; the Menil Collection, Houston; the ICA, London; Arti et Amicitiae, Amsterdam; the Whitney Museum of American Art; the Studio Museum in Harlem; Rote Fabrik, Zurich; ICA, Philadelphia; the Brooklyn Museum; MoMA PS1; New World Symphony, Miami; and Sculpture Center, New York. Adkins is a recipient of the Jacob H. Lazarus Rome Prize, a James Baldwin Fellowship from United States Artists, as well as fellowships from the Joan Mitchell Foundation, the National Endowment for the Arts, and the New York Foundation for the Arts. Adkins is Professor of Fine Arts at University of Pennsylvania. *Recital*, a retrospective of his work, was recently presented at the Tang Museum, Saratoga, NY.

John P. Bowles is Associate Professor and Director of Graduate Studies for Art History, University of North Carolina at Chapel Hill. He received his PhD from UCLA in 2002 and is a graduate of the Whitney Museum of American Art's Independent Study Program. His publications include *Adrian Piper: Race, Gender and the Artist's Body* (Duke University Press, 2011) as well as articles and art criticism in *Signs: Journal of Women in Culture and Society*, *American Art*, *Art Journal*, *Art in America*, and *Art Papers*, among others. He is currently working on his second book, *Globalization and African American Art: History and Transnational Dialogue*, in which he explores how African American artists—from the Harlem Renaissance of the 1920s until today—have engaged simultaneously with modernism, globalization, and diaspora.

Elaine Carberry graduated from Brown University in 2006 with a Bachelor of Arts in Gender Studies. A performance art history scholar and a multidisciplinary artistic collaborator, her interests lie in theorizations of abjection, staged relating, and the somatics of spectacle.

Gary Carrion-Murayari currently holds the position of Curator at the New Museum in New York. Recently he has organized the exhibitions *Spartacus Chetwynd: Home Made Tasers*, *David Medalla: Cloud Canyon, Elizabeth Price: Choir, Enrico David:* *Head Gas*, and *Phyllida Barlow: siege*. He was also co-curator of the group exhibition *Ghosts in the Machine*. Prior to his position at the New Museum, Carrion-Murayari was part of curatorial staff of the Whitney Museum of American Art from 2003 to 2010, where he co-organized the 2010 Whitney Biennial, among other exhibitions.

Huey Copeland is Assistant Professor of Art History and Affiliated Faculty in African American and African Diaspora Studies at Northwestern University. His research and teaching focus on modern, contemporary, and African American art with an emphasis on articulations of blackness in the visual field. Copeland is a regular contributor to *Artforum*, and his recent publications also include features in *Art Journal*, *Callaloo*, *Qui Parle*, *Parkett*, *Representations*, *Small Axe*, and the award-winning edited volume *Modern Women: Women Artists at the Museum of Modern Art*. His first book, *Bound to Appear: Art, Slavery, and the Site of Blackness in Multicultural America*, is forthcoming from the University of Chicago Press.

Adrienne Edwards works with Performa, the visual art performance biennial, and is pursuing her PhD in Performance Studies at New York University, where she is a Corrigan Doctoral Fellow. She has written on the work of Lorraine O'Grady and Tracey Rose.

Sherman Fleming seeks to create projects that identify cultural and social mechanisms that resonate with his processes of visual arts, performance practice, and collaboration, combined with his experiences of community engagement.

Maren Hassinger lives and works in New York. She makes sculptures, installations, and performances. Hassinger has been widely exhibited in the United States and abroad. Recent exhibitions include the 2012 Havana Biennial and *Now Dig This!: Art and Black Los Angeles, 1960–1980* at the Hammer Museum, Los Angeles, which traveled to MoMA PS1 in 2012. She is the recipient of many awards and honors including the Louis Comfort Tiffany Foundation Grant, the Lifetime Achievement Award from the Women's Caucus for the Arts, and Anonymous was a Woman. Since 1997 she has been Director of Graduate Sculpture at the Maryland Institute College of Art in Baltimore.

Ryan Inouye is Curatorial Assistant in the Department of Education and Public Programs at the New Museum, where he has coordinated Museum as Hub projects since August 2010. Most recently, he worked with Eungie Joo as Curatorial Assistant on *The Ungovernables*, the 2012 New Museum Triennial. With Ethan Swan, Inouye co-curated the exhibition *Museum as Hub: Steffani Jemison and Jamal Cyrus: Alpha's Bet Is Not Over Yet!* (2011). Prior to his work at the New Museum, Inouye served as Curatorial Assistant at REDCAT, Los Angeles. He has contributed writing to exhibition catalogues and brochures on the work of Abraham Cruzvillegas, Dave McKenzie, Steffani Jemison, and Apichatpong Weerasethakul.

Steffani Jemison lives and works in Brooklyn, NY. An alumnus of Columbia University and the School of the Art Institute of Chicago, Jemison has recently participated in exhibitions at the New Museum and the Studio Museum in Harlem, and residency programs at the Museum of Fine Arts Houston,

Project Row Houses, and the International Studio and Curatorial Program. She is also the editor of Future Plan and Program, a publishing project featuring literary work by visual artists.

Kellie Jones is a scholar and curator. She is Associate Professor in the Department of Art History and Archaeology at Columbia University, where she specializes in African American and African Diaspora artists, Latino/a and Latin American artists, and issues in contemporary art and museum theory. Her writings have appeared in numerous exhibition catalogues and journals. Her book *EyeMinded: Living and Writing Contemporary Art* (Duke University Press, 2011) was named one of the top art books of 2011 by Publishers Weekly. A curator for over three decades, Jones has organized exhibitions both nationally and internationally. Her most recent show, *Now Dig This! Art and Black Los Angeles, 1960–1980*—part of the Getty Foundation's Pacific Standard Time initiative— opened at the Hammer Museum in 2011 and traveled to MoMA PS1 in 2012.

Thomas J. Lax is Exhibition Coordinator and Program Associate at the Studio Museum in Harlem. His interests include contemporary art and critical theory, with a particular focus on performance and video. At the Studio Museum, he has organized exhibitions including *Mark Bradford: Alphabet* (2010), *Lyle Ashton Harris: Self/Portrait* (2011), *Ralph Lemon: 1856 Cessna Road* (2012) and *Kalup Linzy: If it Don't Fit* (2008), among others. In addition to coordinating the do-and-think tank Studio Lab at the Museum, he organized *OFF/SITE* (2010–11), a year-long collaboration with the Goethe-Institut, New York. He has also written for artist monographs locally and internationally at venues including Artists Space, New York; Cuchifritos, New York; Kunstnernes Hus, Oslo; Real Art Ways, Hartford; and Rush Arts Gallery, New York. He received his BA from Brown University in Africana Studies, and will receive an MA in Modern Art from Columbia University in 2012.

Christopher Y. Lew is Assistant Curator at MoMA PS1. He joined the museum in 2006, and recently organized *Clifford Owens: Anthology* and *Nancy Grossman: Heads* (with Klaus Biesenbach) as well as projects by Edgard Aragón, Rey Akdogan, Ilja Karilampi, and Caitlin Keogh. He has also curated exhibitions and programs in New York City at venues including Artists Space and Aljira, and has written broadly.

Bernard Lumpkin serves on the Acquisition Committee at the Studio Museum in Harlem, the Print Committee at the Whitney Museum, and the Friends of Education at the Museum of Modern Art, where he produces public programs on African American artists.

Matthew McNulty lives in New York.

Lorraine O'Grady was born in Boston, MA to West Indian parents. She began her education with economics and literature. She proceeded to work as an intelligence analyst for the United States government, a literary commercial translator, and rock critic—a broad background that contributed to a distanced and critical view of the art world. Concerned with the lack of African American representation in the Feminist movement of the 1970s, she critiqued the effort's inability to "make itself meaningful to working-class white women and to non-white women of all classes." O'Grady has maintained

an ongoing commitment to articulating "hybrid" subjective positions that span a range of races, classes, and social identities. In addition to her work as a visual artist, O'Grady has also made innovative contributions to cultural criticism with her writings, including the now-canonical article "Olympia's Maid: Reclaiming Black Female Subjectivity."

Clifford Owens lives and works in Queens, NY. The exhibition *Clifford Owens: Anthology* at MoMA PS1 was his first solo exhibition at a New York museum. Owens also had a one-person show at the Contemporary Art Museum Houston in 2011. He has been exhibiting work since 2001 and has participated in exhibitions at the Studio Museum in Harlem, the Queens Museum of Art, the Kitchen, and the MIT List Visual Art Center, Cambridge, MA. Owens was featured in *Greater New York* 2005 at MoMA PS1.

Kate Scherer is an independent producer based in New York. She has realized artists' exhibitions, publications, and releases for MoMA PS1; The Aldrich Contemporary Art Museum, Ridgefield, CT; ARTPIX, Houston; On Stellar Rays, New York, among others. She is a contributing writer for the 2012 *Yale Painting and Printmaking MFA Catalog*, and an ongoing member of the Kate Bush Dance Troupe.

Gabriela "Gabi" Scopazzi was born in Lima, Peru. She recieved her BFA in Studio Art from New York University in 2012. She currently lives and works in Brooklyn.

Lanka Tattersall is a Curatorial Assistant in the Department of Painting and Sculpture at MoMA and a graduate student in the Department of History of Art and Architecture at Harvard University. Her research focuses on modern and contemporary art, with a particular emphasis on the intersection of abstraction and performance in critically engaged artistic practices. She holds a Master's degree in Modern Art and Curatorial Studies from Columbia University, where she completed a thesis on Lynda Benglis's videos from the early 1970s.

Eugenie Tsai joined the Brooklyn Museum in 2007 as John and Barbara Vogelstein Curator of Contemporary Art. She has organized several exhibitions from the Museum's collection, including *21: Selections of Contemporary Art from the Brooklyn Museum* (2008), *Extended Family* (2009), *That Place* (2010), and *Unfolding Tales* (2011). In fall 2011 she organized *Sanford Biggers: Sweet Funk—An Introspective*, *Lee Mingwei: The Moving Garden*, and initiated *Raw/Cooked*, a yearlong series of projects by five under-the-radar Brooklyn artists. Among the exhibitions and installations she has organized are the midcareer survey *Threshold: Byron Kim, 1990–2004* and the retrospective *Robert Smithson*, which received the International Association of Art Critics' first place award for the best monographic exhibition of 2005. Tsai received a BA from Carleton College in Northfield, Minnesota, and a PhD from Columbia University.

Clifford Owens: Anthology
MoMA PS1 exhibition checklist
November 13, 2011–May 7, 2012

Anthology (Benjamin Patterson)
2011
Vinyl print on floor
Dimensions variable

Anthology (Charles Gaines)
2011
Digital audio
4 minutes, 29 seconds

Anthology (Dave McKenzie)
2011
15 C-prints
16 x 20 inches each

Anthology (Derrick Adams)
2011
31 C-prints
10 x 8 inches each

Anthology (Glenn Ligon)
2011
3 C-prints
30 x 40 inches each

Anthology (Jacolby Satterwhite)
2011
Polaroid and C-print
Polaroid: 3 ½ x 4 inches; C-print: 30 x 40 inches

Anthology (Jennie C. Jones)
2011
C-print
30 x 40 inches

Anthology (Jennie C. Jones)
2011
HD video
1 minute, 23 seconds

Anthology (Kara Walker)
2011
5 C-prints and HD video
C-prints: 16 x 24 inches each; video: 3 minutes,
41 seconds

Anthology (Lorraine O'Grady)
2011
3-channel HD video
24 minutes, 44 seconds

Anthology (Maren Hassinger)
2011
3 C-prints
20 x 24 or 24 x 20 inches each

Anthology (Maren Hassinger)
2011
HD video
25 minutes, 35 seconds

Anthology (Nsenga Knight)
2011
2 C-prints
40 x 60 inches each

Anthology (Rico Gatson)
2011
C-print
30 x 40 inches

Anthology (Sanford Biggers)
2011
Digital audio
3 minutes, 29 seconds

Anthology (Senga Nengudi)
2011
2 C-prints
30 x 40 inches each

Anthology (Sherman Fleming)
2011
67 C-prints
5 x 7 inches each

Anthology (Steffani Jemison)
2011
3 C-prints
16 x 20 inches each

Anthology (Terry Adkins)
2011
C-print, digital audio, and speaker
C-print: 30 x 40 inches; audio: 3 minutes,
38 seconds

Anthology (William Pope.L)
2011
20 archival pigment prints
13 ½ x 9 or 9 x 13 ½ inches each

All works courtesy the artist.

Published as a companion to the exhibition *Clifford Owens: Anthology*, curated by Christopher Y. Lew and organized by MoMA PS1, Long Island City, New York.

November 13, 2011–May 7, 2012

The exhibition and publication are made possible by MoMA's Wallis Annenberg Fund for Innovation in Contemporary Art through the Annenberg Foundation.

Additional funding for the exhibition is provided by The Friends of Education of The Museum of Modern Art and by Bernard Lumpkin and Carmine Boccuzzi.

Published by MoMA PS1
22-25 Jackson Avenue
Long Island City, NY 11101
www.momaps1.org

ISBN-13: 978-0-9841776-6-0
ISBN-10: 0-9841776-6-3

EXCAT

Exhibition
Curator: Christopher Y. Lew
Registrar: Jen Watson
Chief of Installation: Richard Wilson
Head Preparator: David Figueroa

Catalogue
Editor: Christopher Y. Lew
Design: Andy Pressman/Rumors
Copyeditor: Rachel Wetzler

Printed by The Avery Group at Shapco Printing, Minneapolis. Typeset in Atlas Grotesk and Atlas Typewriter, designed by Kai Bernau, Susana Carvalho and Christian Schwartz.

Available through D.A.P./Distributed Art Publishers
www.artbook.com

709.2 OWE

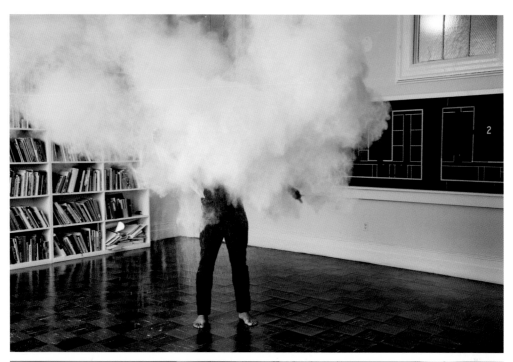

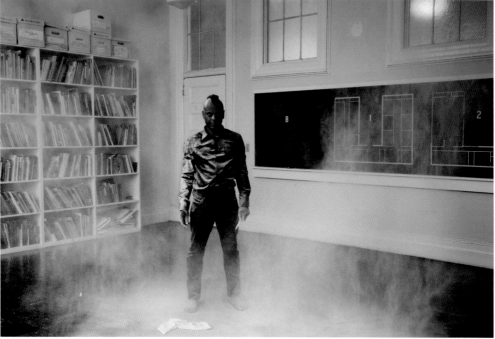

Anthology (Jacolby Satterwhite)

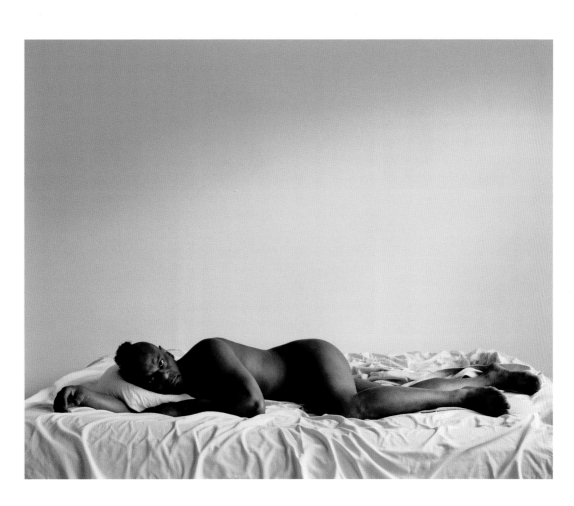

Anthology (Maren Hassinger)

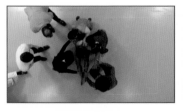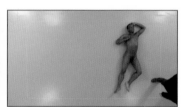

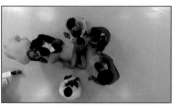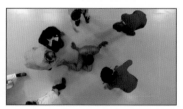

c

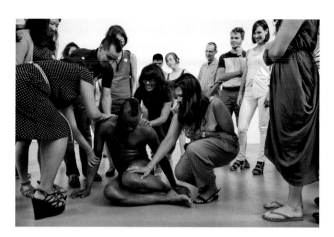

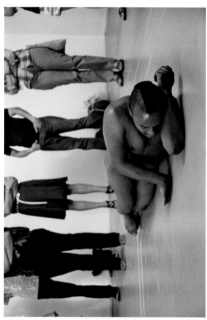

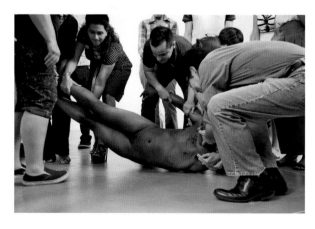

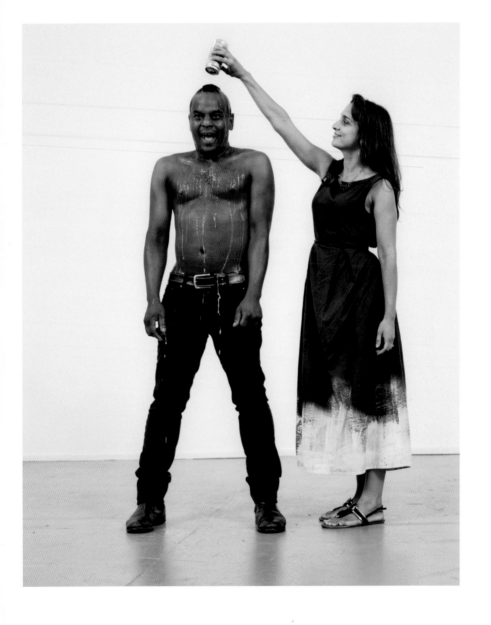

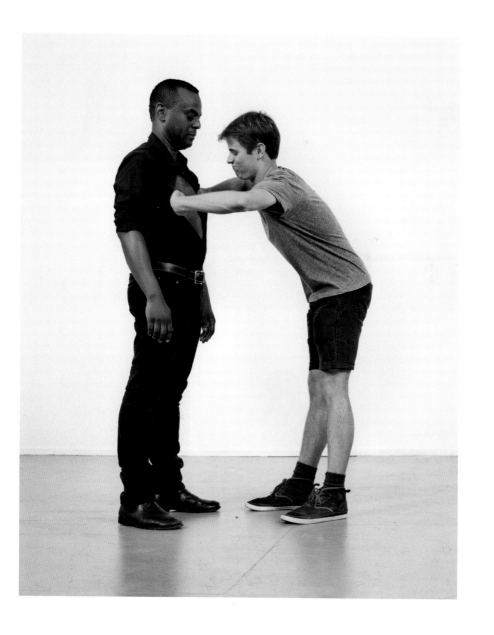

Anthology (Jennie C. Jones)

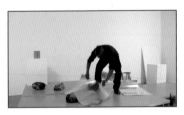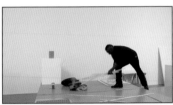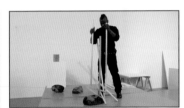

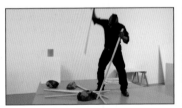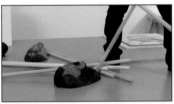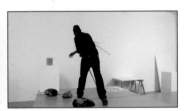

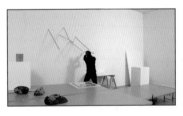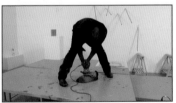

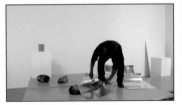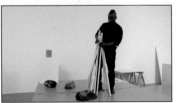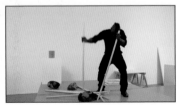

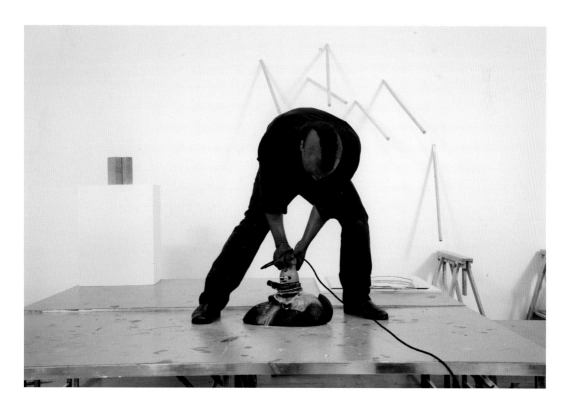

Anthology (Dave McKenzie)

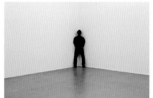

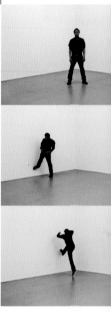

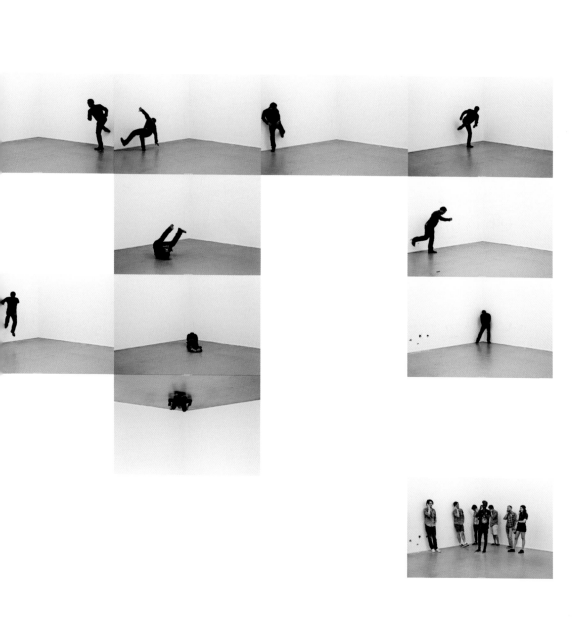

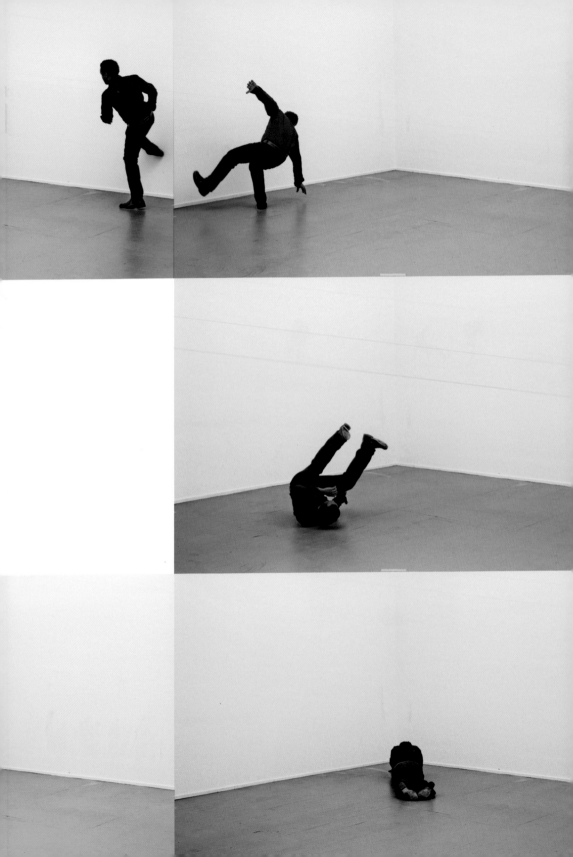

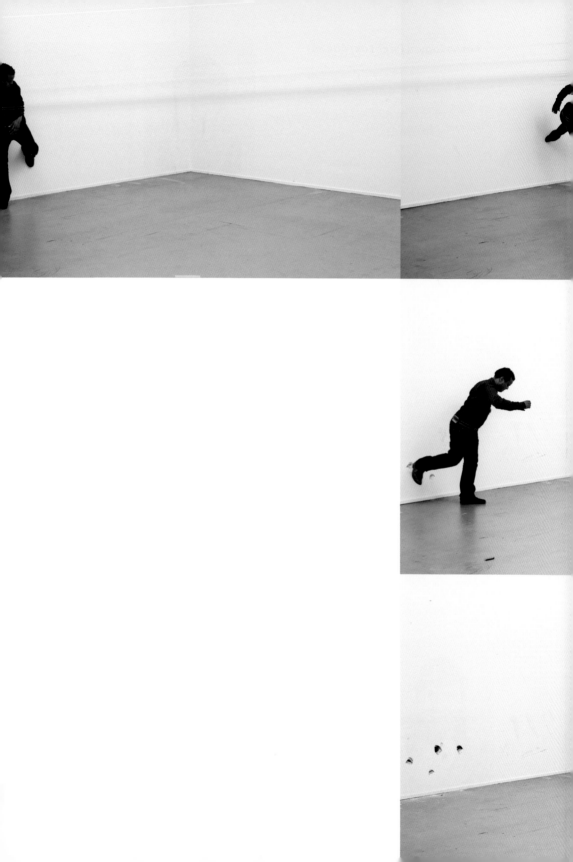

Anthology (Derrick Adams)

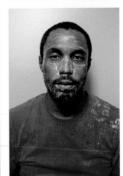
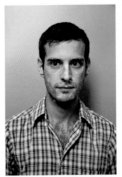
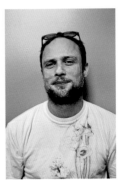
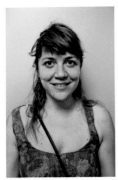

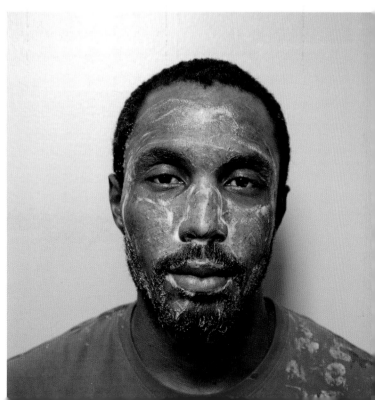

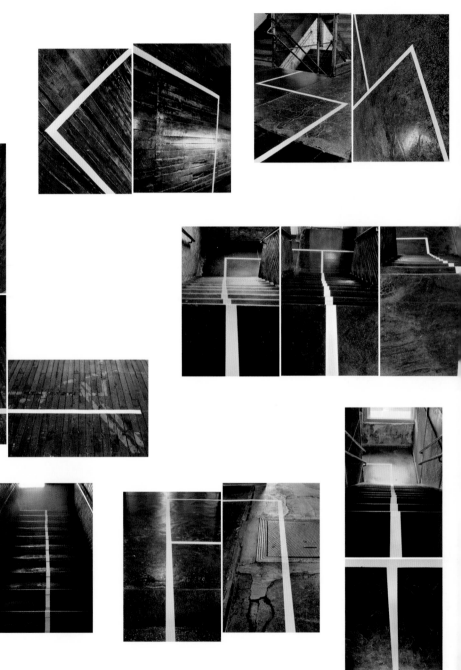

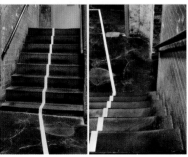

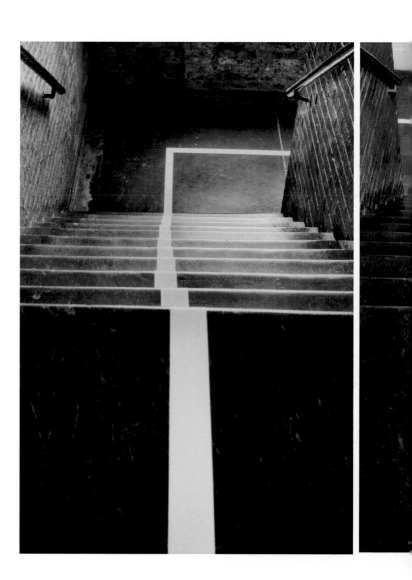

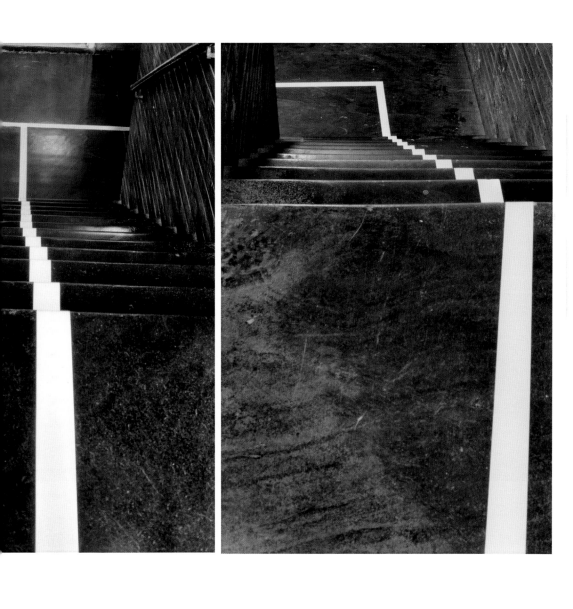

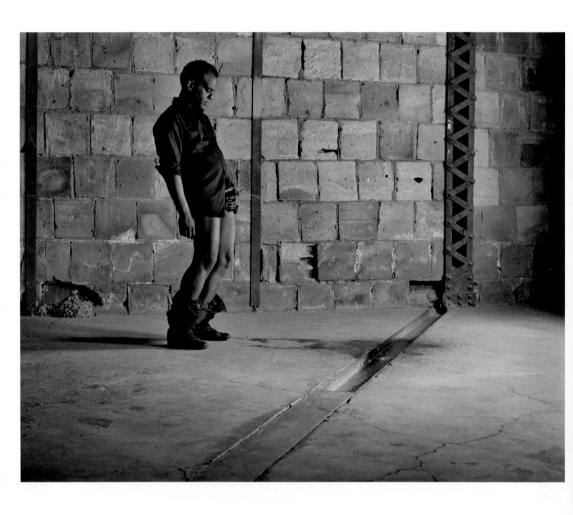

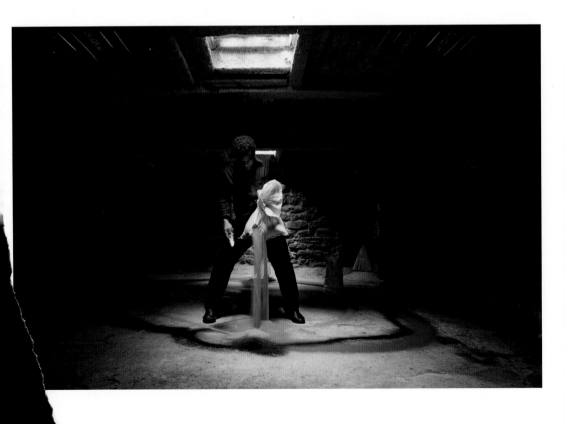

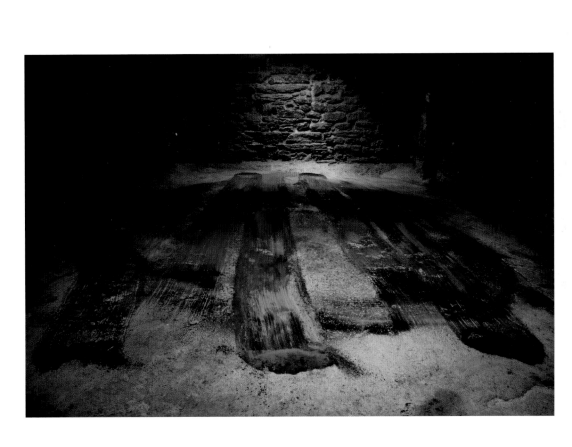

NIGGER

NIGGER

NIGGE

NIGG NIG NI N

Anthology (Kara Walker)

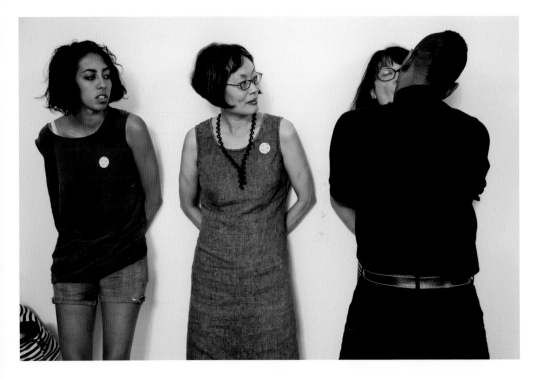

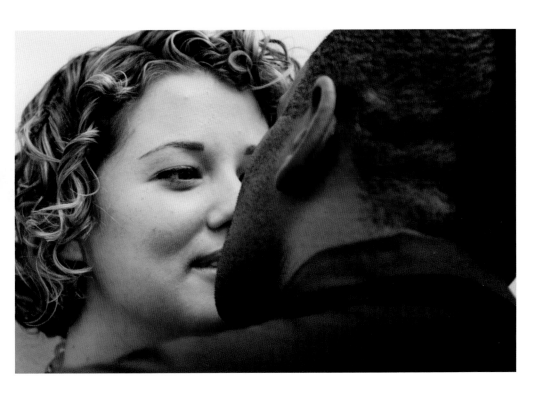

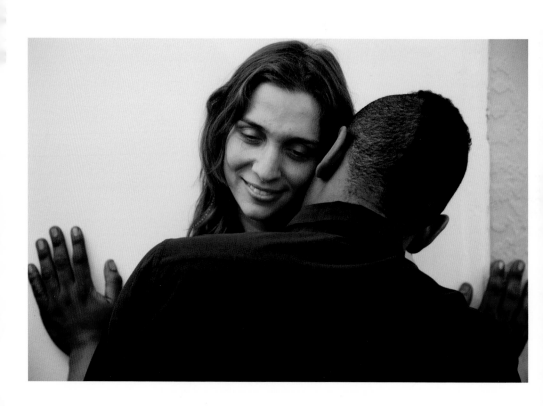

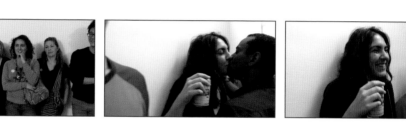

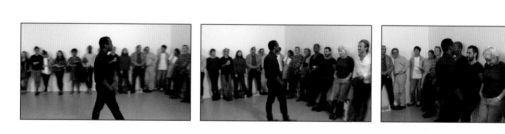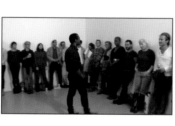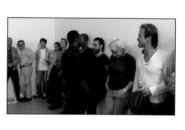

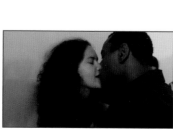

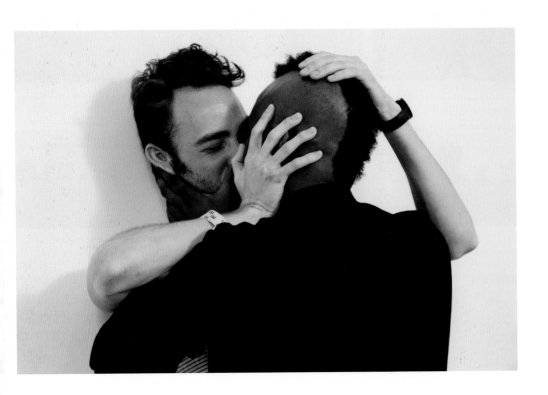

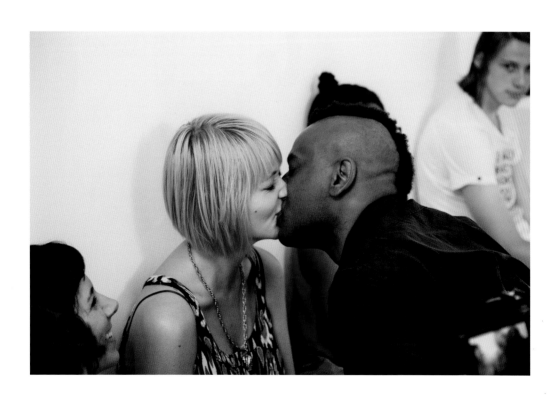

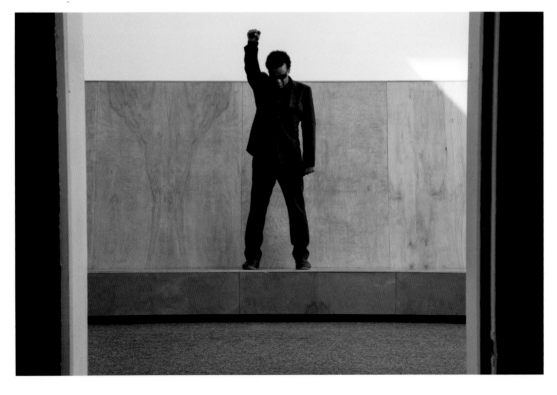

t

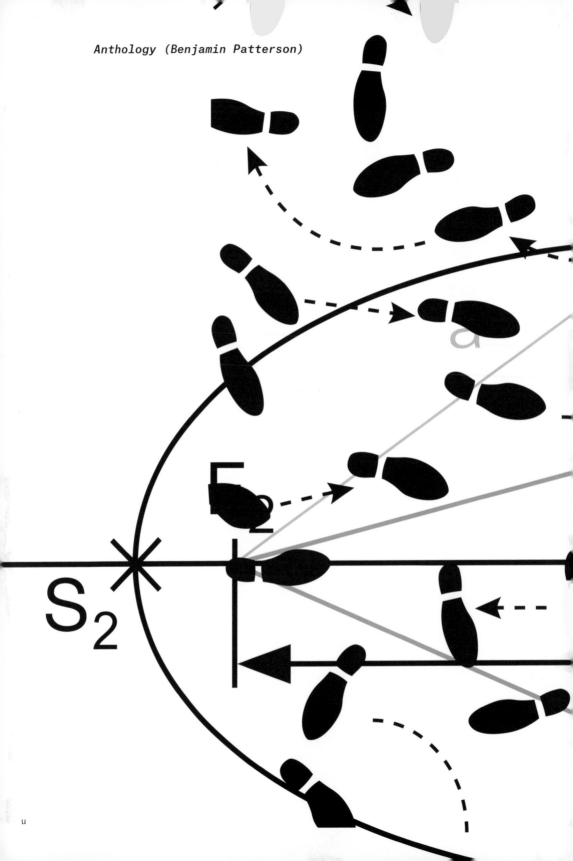

Anthology (Benjamin Patterson)

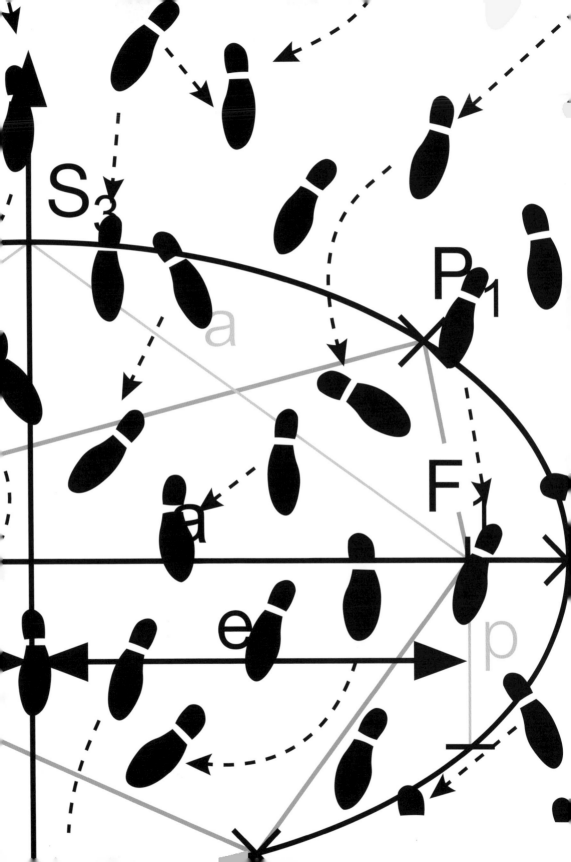

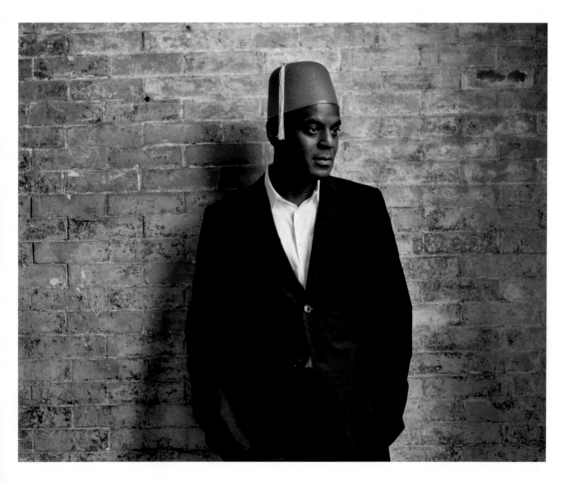

Anthology (Lyle Ashton Harris)

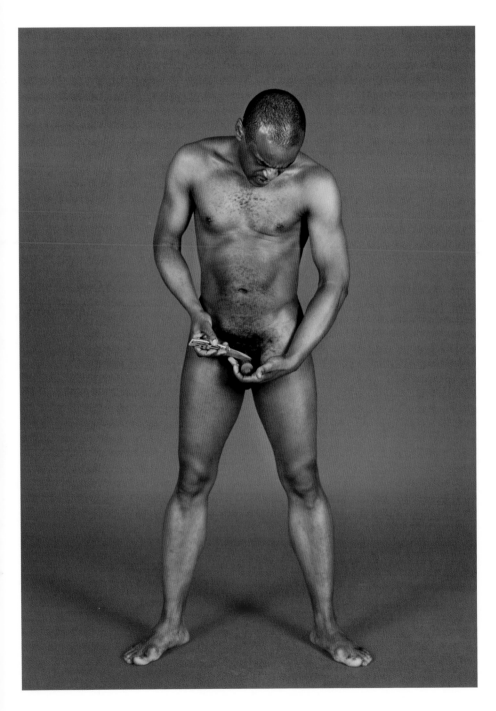

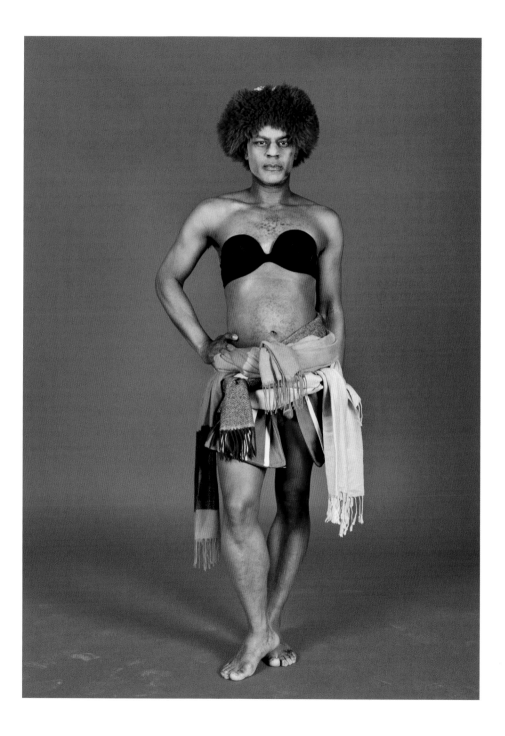

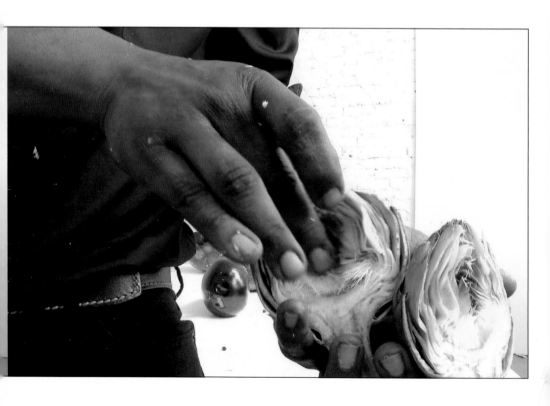

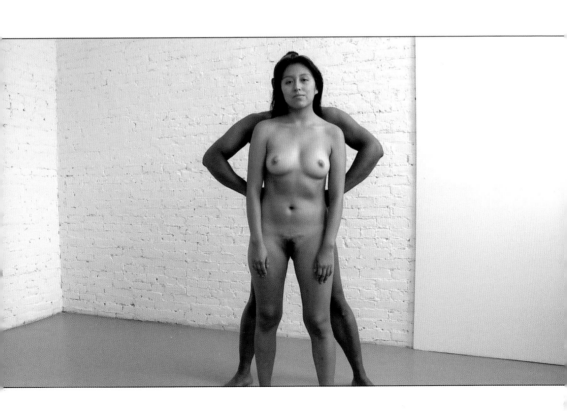